IMAGES
of America

ASHLAND

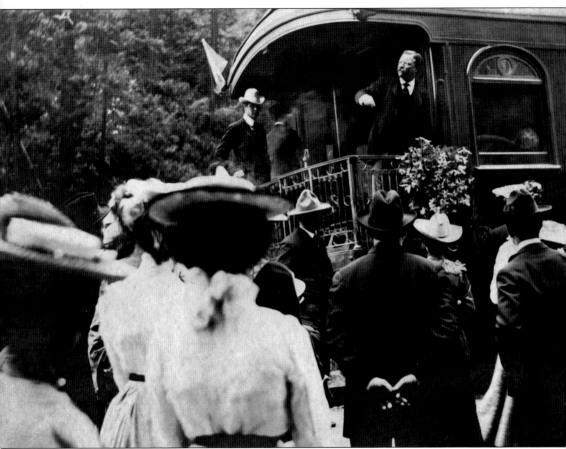

Between 1880 and 1919, five sitting presidents of the United States made stops in Ashland: Rutherford B. Hayes, Benjamin Harrison, Theodore Roosevelt, William Howard Taft, and Woodrow Wilson. Strategically located near the Oregon-California border, Ashland was a required stop before or after climbing the Siskiyou Mountains. Pictured is Teddy Roosevelt's 1903 visit to Ashland, which drew an estimated crowd of 6,000! (Courtesy of author's collection.)

ON THE COVER: By 1911, Ashland's Plaza reflected the enormous transition occurring in transportation. Horse-drawn buggies coexist with horseless carriages in this photograph. It would only be a short time before automobiles became dominant in Ashland as well as the rest of America. Blacksmith and wagon-maker Emil Peil would need to adapt by selling the new machines, which were limited to 5 miles per hour within 100 feet of a horse. (Courtesy of Terry Skibby.)

IMAGES
of America

ASHLAND

Joe Peterson

ARCADIA
PUBLISHING

Copyright © 2009 by Joe Peterson
ISBN 978-0-7385-7102-7

Published by Arcadia Publishing
Charleston SC, Chicago IL, Portsmouth NH, San Francisco CA

Printed in the United States of America

Library of Congress Control Number: 2009920383

For all general information contact Arcadia Publishing at:
Telephone 843-853-2070
Fax 843-853-0044
E-mail sales@arcadiapublishing.com
For customer service and orders:
Toll-Free 1-888-313-2665

Visit us on the Internet at www.arcadiapublishing.com

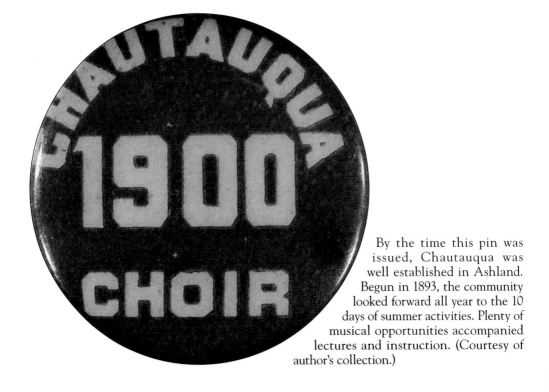

By the time this pin was issued, Chautauqua was well established in Ashland. Begun in 1893, the community looked forward all year to the 10 days of summer activities. Plenty of musical opportunities accompanied lectures and instruction. (Courtesy of author's collection.)

CONTENTS

ACKNOWLEDGMENTS

Terry Skibby has devoted his entire adult life to the collection and maintenance of historic images of his hometown. Terry's collection is vast and consists of original glass plates, negatives, and photographs he has acquired over a 40-year time span. Thousands of images are in his personal collection, and all of us who treasure Ashland history are in his debt for so doggedly preserving the past. The vast majority of the photographs in this volume are here with his permission. Unless otherwise noted, all images appear courtesy of Terry Skibby.

The Oregon Shakespeare Festival's archivist, Kit Leary, has documented the festival brilliantly over the years. Several photographs in the last two chapters are here with the permission of the Oregon Shakespeare Festival (OSF), as noted in the captions.

Two individuals who have chronicled Ashland's history and whose previous extensive research was especially helpful are Marjorie O'Harra and Kay Atwood. Their main works on Ashland history are referenced in the selected bibliography. Jeff LaLande, Bert Webber, Janelle Davidson, Larry Mullaly, Lance Pugh, Victoria Law, Arthur Kreisman, Sue Waldron, Donn Todt, Molly Kerr, and George Kramer have also written on various aspects of Ashland's history, and their perspectives have been useful as well.

Reservoirs of information on Ashland history include the Oregon Shakespeare Festival's archives, the Southern Oregon Historical Society's research library, the Ashland Historic Railroad Museum, the Ashland Public Library, and Southern Oregon University's Hannon Library.

INTRODUCTION

"Ashland wasn't much of a town when I was a girl; I never expected it to be much of a town. My grandfather would be surprised to see it because he never dreamed Ashland would be a town like it is." Born February 4, 1891, in the town founded by her grandfather, Almeda Helman Coder provided this observation in an *Ashland Tidings* interview while turning 100 years of age in 1991.

From earliest times, when a handful of disgruntled California gold miners (including Almeda's grandfather) decided that outfitting others was far preferable to moving from goldfield to goldfield themselves in quest of elusive wealth, Ashland has sought to draw in those who were on their way to somewhere else. Initially mills were built and a hotel established to supply nearby Jacksonville and cater to those along the stage route. Later, with the coming of the railroad and a division headquarters established in Ashland, nearly a separate town sprang up below the stage road and along the tracks to serve a new army of railroad workers and daily batches of visitors. Lithia water was piped to a peeled-log kiosk near the depot so visitors might sample the "healing waters" native to the valley.

With the establishment of Chautauqua Park—and later Lithia Park and a health spa concept to complement an already successful, established Chautauqua summer program—Ashland would claim itself to be the "Cultural Capital of Southern Oregon" early on. Even with the demise of the Chautauqua circuit and the failure of proponents of a "Saratoga Springs of the West Coast," Angus Bowmer and Shakespeare were not far behind. Ashland, it seems, has always been solicitous of and dependent to some degree on outsiders, trying to capture the revenue they might bring.

Despite Mrs. Coder's childhood memories of a rather bleak hometown, surely a progressive stream can be seen in a town that owned its own electric utility a couple of decades before the New Deal; voted for reformer Teddy Roosevelt in 1912 while the rest of the country and state did not; and has supported and nurtured its college with cash and land donations throughout its history. In addition, into what kind of an environment could a Shakespeare festival spring in the middle of a devastating depression if not a receptive and open one?

On the other hand, contrary evidence also exists that Ashland remained a typically conservative and not particularly tolerant small town until very recent times. It was a place where its Commercial Club brochures stressed its desirability because of the lack of ethnicity and where Ku Klux Klan members proudly paraded in full hoods and robes on the Fourth of July. As late as the 1960s, "Shakespeares" was a derisive term for the summer theater troupe, and a local group even organized to oppose the city's efforts to help fund the new indoor Bowmer Theatre.

Despite these two disparate views of the town's history, there does seem to be agreement on the changes that have occurred in recent times. That new indoor theater, an influx of the counterculture, and an equity-swelling California real estate boom all coalesced in such a way as to bring about the Ashland so often written about today. The outdoor-based Shakespeare festival had long since outgrown its ability to satisfy an ever-expanding crowd and, by 1968, was turning away literally thousands of would-be playgoers.

Meanwhile, a still predominately blue-collar town with boarded-up storefronts—because of a previous downturn in fortunes for the countless small sawmills throughout the valley— became a kind of mecca for I-5 corridor-riding counterculture young people looking for cheap rents and an opportunity to try their hand at capitalism. Tourism, generated by an expanded theater venue, meant a variety of interesting hippie-owned shops and a change in the city's core business district.

Further, the new, larger summer crowds needed restaurants and places to sleep in town. William Patton, festival general manager for over 40 years, remembered ticket holders staying in motels from Grants Pass to Yreka, California. At one point, Patton even considered recruiting restaurant owners from Northern California to open a place in Ashland. This proved unnecessary though once the longer, more stable market was recognized. Bed-and-breakfast inns and restaurants such as Chateaulin began to appear in the neighborhoods and business district surrounding the theaters. In addition to the Bowmer Theatre in 1970, the Black Swan opened in 1977, resulting in a total of three playhouses and still more visitors.

When Republican president Rutherford Hayes arrived by stagecoach in nearby Jacksonville, Oregon, on September 27, 1880, there was great apprehension as to how he might be received in that potentially hostile Democratic party stronghold. That same afternoon in Ashland, there had been no such similar anxiety as he spoke on the Plaza. Ashland was an unabashedly Republican town and would remain solidly so for the next 90 years. However, at the nation's bicentennial in 1976, Democrats outnumbered Republicans five to three, and by 2000, it was two Democrats for every Republican, with nearly as many registered "non-affiliated" as registered Republican. A kind of self-selection process was occurring.

The once rough-hewn frontier town of the Helmans' day has become a haven for well-educated, affluent, humanities-oriented retirees. With a college that features theater-oriented classes for older adult visitors and residents with an interest in the performing arts, it is nearly impossible to find a retirement guide that does not rank Ashland, Oregon, near the top in desirability. As Almeda Helman Coder said on her 100th birthday, neither she as a young girl nor her town-founding grandfather could have predicted how Ashland would evolve.

In many ways, Almeda's experiences as a girl growing up seemed to capture the contrast apparent in the different views of Ashland's past. Its progressive strand can be found in the fact that Abel Helman always made sure his granddaughter had a ticket for Chautauqua events. "We used to have very noted people come and put on programs, and grandfather was very much interested in Chautauqua and he liked to pass that on to me," she remembered. Conversely, Almeda learned at an early age that she was not to go near the railroad depot on A Street. As her mother, Grace Helman, admonished, "Nice girls don't go down around where the trains come in." Almeda notes, "We were also told not to walk on the side of the street where the saloons were." Coming from a family with longtime affiliations with both the United Methodist Church and the Women's Christian Temperance Union, a certain amount of provincial caution seemed appropriate.

So what does it all mean? What value, then, is the study of a small western town with seemingly the same number of ups and downs as so many others, a town many folks held limited expectations for, even members of its founding family? The history of Ashland, Oregon, is a local version of American history, complete with uplifting examples of the best of the American spirit and depressing examples of our frailties. History is interpretation, and by exploring local events, either confirmation or a reinterpretation of our national history pageant can occur. That is why the study of a place like Ashland, Oregon, matters.

One

A Town Called Ashland Mills

Abel Helman, fresh from the goldfields of California and the tent town initially called Table Rock City (Jacksonville), remembered previously passing through a nearby valley with an ample water resource. Knowing that those suffering from the gold fever would need lumber, equipment, food, and supplies, Helman, Eber Emery, and a handful of other newcomers scattered about the upper Bear Creek drainage built a primitive, water-powered sawmill along the banks of that tributary creek, soon to be known as Mill Creek. In 1854, a flour mill was added that sat at what today is the entrance to Lithia Park. A year later, this sturdy structure would have an additional purpose—to shelter the approximately 20 settlers in the area from Native American attacks. Similar to other parts of America, a tragic and predictable clash of cultures resulted in deadly skirmishes lasting a few years until most native people were forcibly marched to northern coastal reservations.

With farmers, lumbermen, and miners coming to the mills, coupled with clever entrepreneurship, the area became known as Ashland Mills, a name that stuck until 1871, when "Mills" was dropped in favor of the current name, Ashland. Growth was steady, if unspectacular, as the small town expanded from its Plaza beginnings. Why "Ashland?" Oddly, of the original eight men who decided to stay rather than simply pass through the valley on their way somewhere else, half of them had a connection to an Ashland back in "the states."

Helman and both Eber and Jacob Emery wanted to name their new home for Ashland County, Ohio, where they came from, but James Cardwell, an admirer of three-time presidential Whig candidate Henry Clay, thought it should be named for Clay's Kentucky estate, also named Ashland. Legend has it that straws were drawn and that Ashland County, Ohio, won. Besides the obvious fact that regardless of who won the draw "Ashland" would be the chosen name, the irony is that early Ohio Whig party settlers had previously honored Henry Clay by naming their county Ashland!

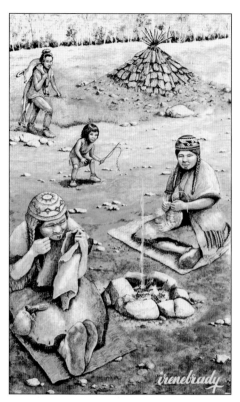

Thousands of years before Euro-American settlement, there is significant archaeological evidence of Shasta Indians residing in a permanent village at the present site of today's Plaza along Ashland Creek. Early settlers also spoke of Klamath Indians coming to Bear Creek to fish and hunt. Tragically, though, decimated by disease and armed skirmishes as part of the southern Oregon Indian Wars, the few surviving native people were forcibly removed to northern reservations. (Courtesy of artist Irene Brady and Ashland Parks Department.)

Lindsay Applegate, migrating west to the Willamette Valley on the established Oregon Trail, lost his son and nephew in the Columbia River. Deciding there had to be a better, safer course, Lindsay and his brother Jesse devised a new southern route eventually called the Applegate Trail, which brought large numbers of settlers and miners through the area, resulting in an inevitable clash with native inhabitants.

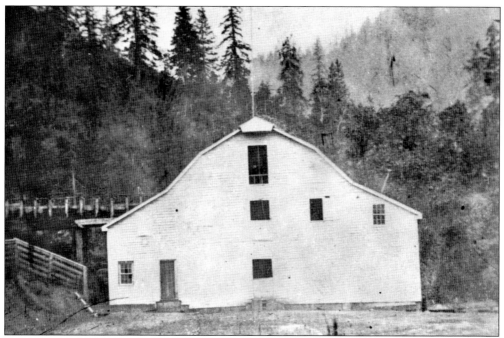

Built in 1854 by Abel Helman, Eber Emery, and M. B. Morris, this flour mill was powered by water from Mill Creek (Ashland Creek) and stood at the entrance of today's Lithia Park. The first flour milled here in the fall of 1854 came from the E. K. Anderson farm. The structure also served as a fortification against attacks from native people in its first years of existence. Families had marked-off areas inside the mill to assemble.

This is the earliest picture of Ashland's Plaza known to exist, taken in the early 1860s. Identifiable is Ashland House on the right, and behind it is Hargadine's 1859 store near the present site of city hall. Abel Helman started a primitive business district here when he made land available for shops and stores in front of his flour mill.

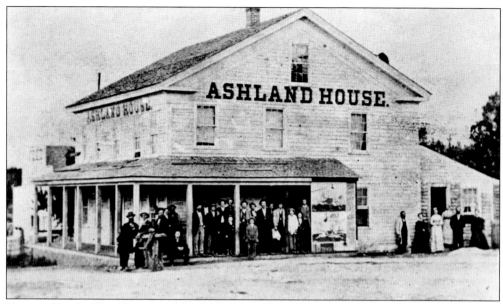

Town cofounder Eber Emery's Ashland House may have been the town's first bed-and-breakfast, opened for business in 1860 along the stage road (Main Street) to entice travelers. The building was moved twice and finally torn down 100 years later in 1960 after having been transported to the railroad district.

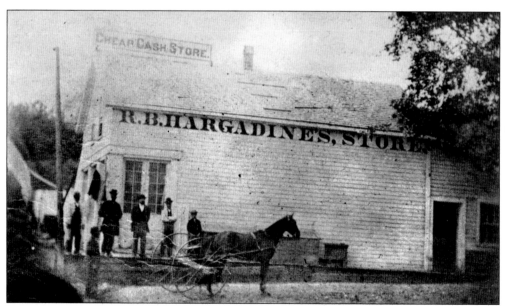

Pictured on the Plaza is Robert Hargadine's general store. This area near the flour mill was becoming a fledgling outfitting center. Wooden buildings were more plentiful, and boardwalks were constructed in an effort to avoid the mud-laden streets. Note the roof advertisement that his was a "Cheap Cash Store."

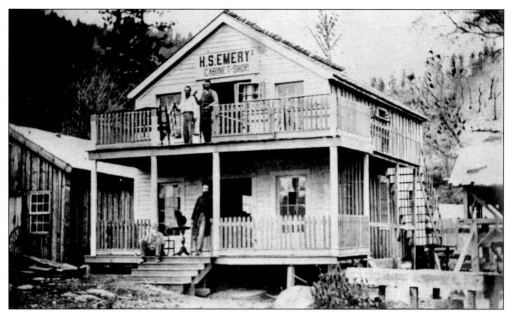

In 1852, J. B. Emery, Eber Emery, and Helman built the first sawmill in the area, resulting in several wooden structures, including both shops and houses. Pictured is a cabinet shop on the Plaza around 1870. Finished wood products were in great demand throughout the valley.

At the most recent count, 27 towns or counties in the United States are named Ashland in honor of Henry Clay, candidate for president three times before the Civil War. Clay's country estate in Kentucky was named Ashland for its abundant trees, and Clay enthusiasts named their new town sites after the estate of the man they most admired.

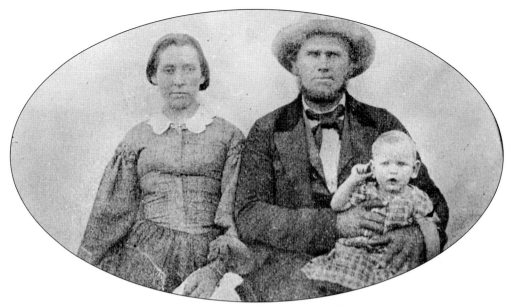

Abel Helman is pictured as a young man with his wife, Martha, and child and later in life in front of his home with his son Grant and Grant's two daughters. Abel had returned to Ohio for a visit in the 1870s and brought back Osage orange trees, as well as hickory nuts, black walnuts, and pawpaw trees. The Helmans' son John, born in 1854, was the first Euro-American child born in the new settlement of Ashland Mills. Despite being generally regarded as the town founder, trusted postmaster, and generous benefactor, an early murder has been linked to him. No one was ever prosecuted for the crime. Kay Atwood has done extensive research on this murder mystery in her 1987 book *Mill Creek Journal*.

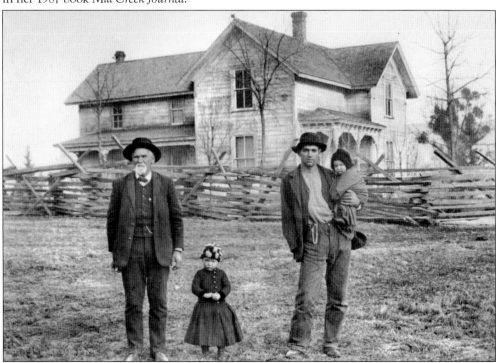

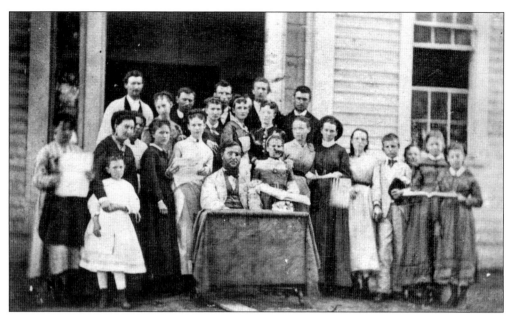

While the first school in the rough-hewn village of Ashland Mills was taught in an early settler's home, by 1860, a wooden structure was in place that cost $596 near Gresham and East Main Streets today. Between 1860 and 1862, twenty students attended. Here, Professor Roughton, a blind music teacher, sits with his class.

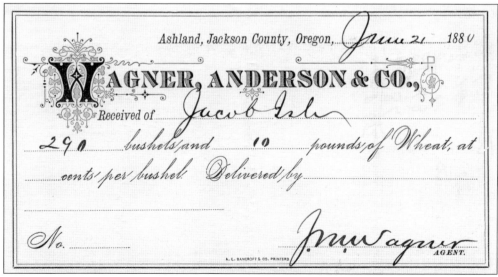

Jacob Wagner and E. K. Anderson owned the flour mill in 1876. Anderson's farm had previously produced the first wheat ever processed at the Ashland mill. In 1879, the local paper reported more wheat coming to town than could be stored before milling. Pictured is an actual mill receipt. (Courtesy of author's collection.)

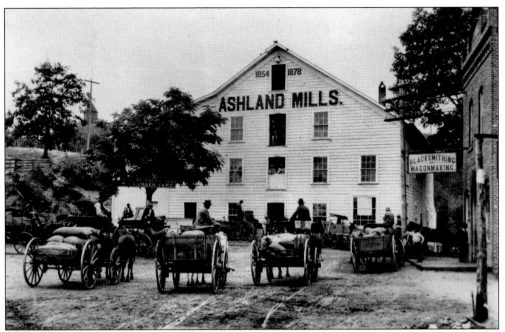

By 1878, the flour mill had been remodeled. In this mid-1890s photograph, the Chautauqua building's cupola can be seen in the background to the left of the mill. In 1894, Almeda Helman, age three, fell into the mill race and was carried 50 feet through the covered flume! Stopped only by a leaf rack designed to keep debris out, she was found screaming but unhurt.

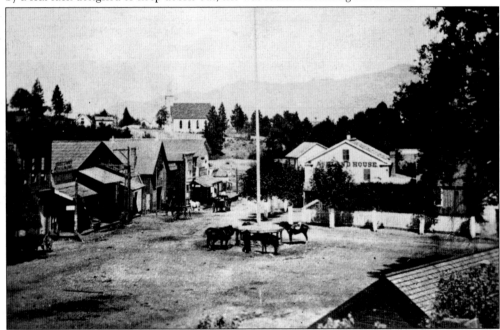

In this 1878 photograph, a more substantial look characterized the Plaza. It was becoming the place where residents scattered about the valley came for supplies. The newly built Presbyterian church building is visible on the hill in the center background. One short year later, most of these wooden storefronts would be destroyed in a spectacular blaze.

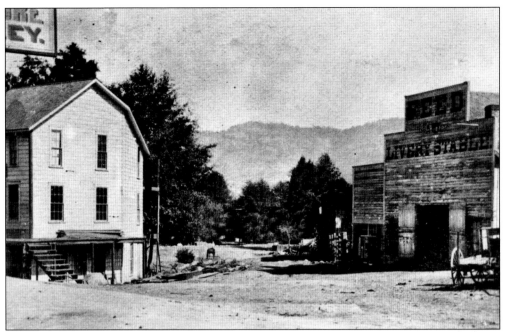

Ashland Woolen Mill is hidden behind and to the left of the Central Hotel, pictured on Water Street in this view from the Plaza. The photograph reveals just how undeveloped Water Street below the stage road (Main Street) was in 1878. The Feed and Livery Stable appears to be the only other established business.

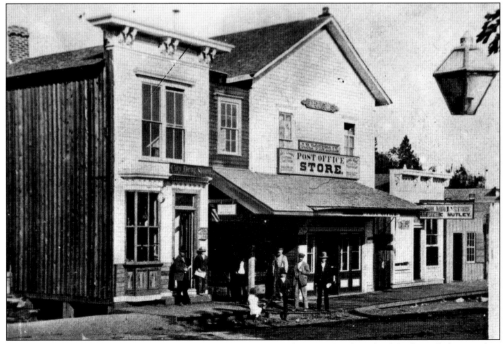

Here is a close-up of Plaza businesses just before a March 1879 fire hit the block. While wooden sidewalks and mud characterized Plaza streets, businesses included a drugstore, post office, and general store, as well as an Odd Fellows Hall, all housed in wood-frame structures.

South and above the Plaza business district along today's Winburn Way, a planing mill and wood-working plant existed from at least the 1870s to the early 1900s. The site later became the location for the Butler-Perozzi Fountain when Lithia Park was developed further upstream from the original Chautauqua Park. Forest land was plentiful throughout Jackson County, as had been noted in the journal accounts of several early future entrepreneurs. Milled timber was in great demand throughout Southern Oregon as town business districts, mining operations, schools, church buildings, and home builders all sought something more refined than the previously rough-hewed material available.

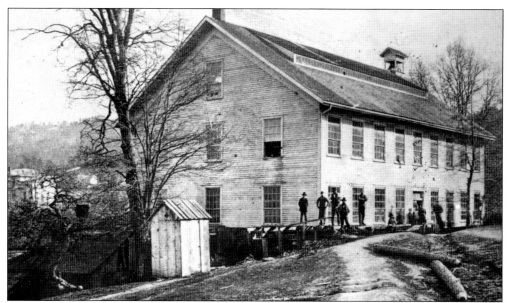

Begun in 1867 and presided over by John McCall, the Ashland Woolen Mill was housed in a three-story wood structure located near Helman and Water Streets on Mill Creek (Ashland Creek). Receiving orders for blankets and socks from as far away as Kansas and even from Goldsmith and Company in Portland, who ordered 200 pairs of blankets at a time, by 1880, Ashland woolen goods were well-known outside the valley and highly respected. The mill operated day and night six days a week with a working crew of 30 employees processing locally produced wool. Now more than ever a multiple mill town, "Mills" would ironically be dropped from the town name just four years after the addition of this major employer. On January 21, 1900, after more than 30 years as a manufacturing center, Ashland residents, awakened by the sound of a fire bell, found the woolen mill totally engulfed in flames.

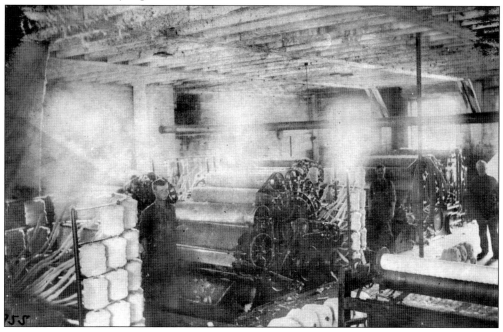

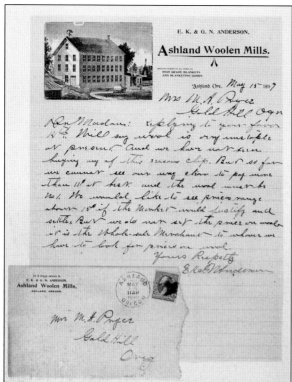

This letter, sent just seven months before the woolen mill burned, was an answer to an inquiry from Gold Hill about the price of wool. Eleven cents a pound was the best price available and only for number one quality. "Wool is very unstable at present and we have not seen buying any of this season's clip," the letter read. (Courtesy of author's collection.)

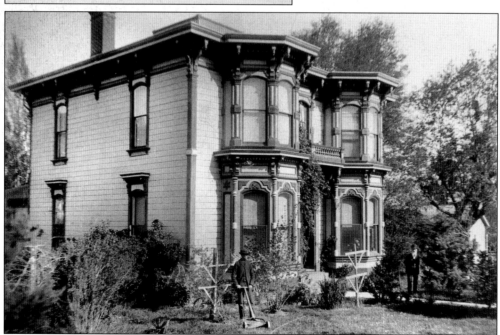

Located at 153 Oak Street, not far from the mill he helped establish, is Ashland Woolen Mills' first president John McCall's 1883 Italianate-style home. McCall was a successful gold miner and later became an Ashland civic leader who helped establish a library, newspaper, and bank, as well as serving as mayor and Oregon state legislator.

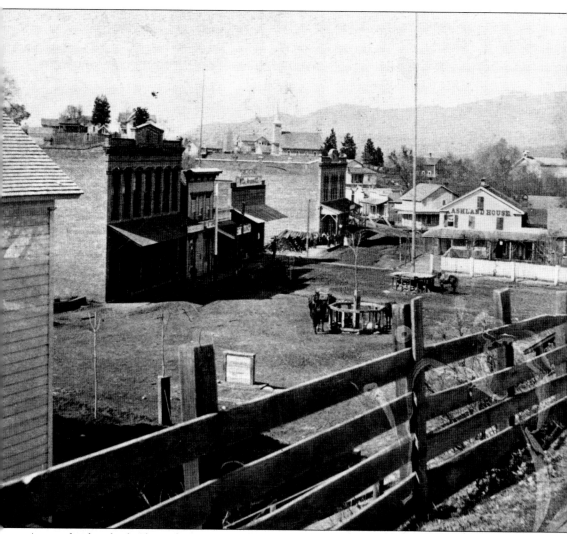

A completely rebuilt Plaza, this time with brick structures following the 1879 fire, was in place when Republican president Rutherford B. Hayes triumphantly entered Ashland atop a six-horse stagecoach on September 27, 1880. Church bells pealed and hurrahs could be heard. It was electric! Ashland's 800 residents were joined by 1,200 others as nearly 2,000 eager onlookers crowded the Plaza to see the president; the first lady, nicknamed "Lemonade Lucy" for her temperance views; and 60-year-old Civil War general William T. Sherman. Standing on a newly built platform at the base of the town flagpole and under a welcoming arch that read "Industry, Education, Temperance—Ashland Honors those Who Foster These" was the president of the United States. The *Ashland Tidings* gushed that the arrival of a president from 3,000 miles away must mean that "time and distance surely have been annihilated!" Visible in this photograph is the town flagpole where the president and Sherman spoke, the new brick Masonic building, and the new IOOF hall.

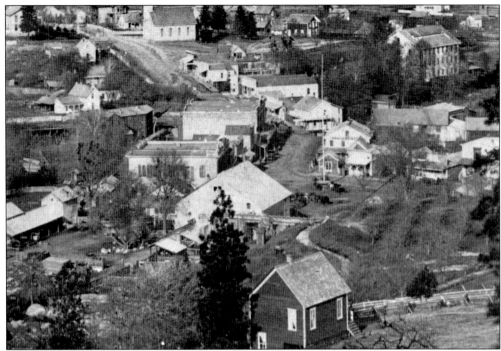

In 1886, both major town mills are in view. In the right background stands the imposing three-story woolen mill, and in the foreground is the back of the flour mill. The latter's wooden flume, into which the Helman child, Almeda, fell, is clearly visible. In the background, left of center, is the eight-year-old Presbyterian church building at Helman and North Main Streets.

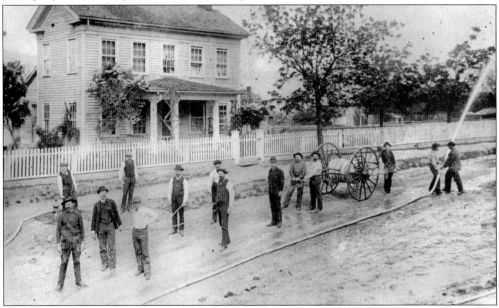

Ashland's volunteer first responders are pictured here with the town hose cart. Though primitive looking, this method was an improvement over previous bucket brigades. Unfortunately these fire-fighting techniques were no match for the blazes that swept Plaza buildings in 1879 and the turn of the century woolen mill fire.

The 1884 Ashland town team is pictured with its star pitcher, George McConnell (first row, right), holding the ball. Armed with McConnell, who could throw what was then called a "curved ball," the cocky Ashland team challenged all comers to a $1,000 to $2,000 match for each of the next several seasons. Note the lack of baseball gloves, as playing with a glove was seen as unmanly. (Courtesy of author's collection.)

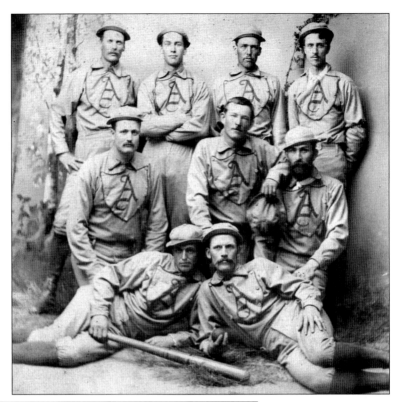

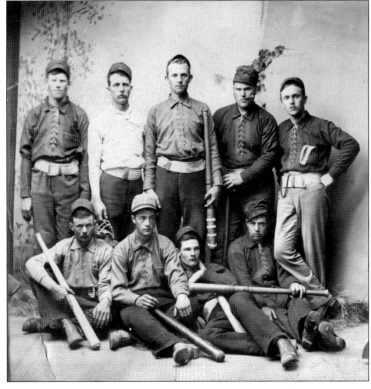

Yreka, California's 1884 town baseball team was soundly defeated by a visiting Ashland nine featuring a pitching sensation who threw a curveball. Yreka players and fans had never seen a pitch move like that and after the game urged Ashland pitcher McConnell to demonstrate how he did it, so they might see for themselves that it wasn't some kind of optical illusion. (Courtesy of author's collection.)

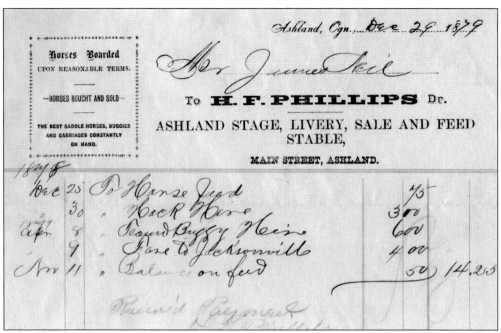

It is sometimes difficult to imagine a world before the existence of automobiles, yet this 1879 invoice/receipt from the Ashland Stage and Livery provides some insight. Horses needed feed, buggies needed equipment, and travel by stage involved a fare. Main Street Ashland was the place to buy horses, tack, buggies, and carriages. (Courtesy of author's collection.)

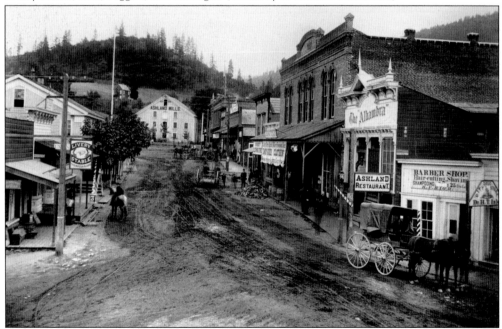

In 1855, Abel Helman laid out 12 lots of his Donation Land Claim in front of the flour mill in hopes that a business district would evolve. This late-1880s view shows that over time, numerous businesses were established; however, saloon wars raged during this period, led by Temperance Union leader Ann Hill Russell, who opposed the sale of alcohol.

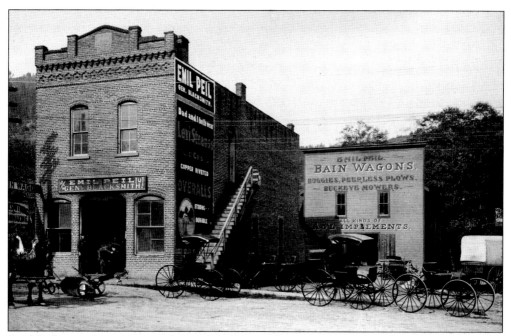

Emil Peil was a businessman who could adapt to change. In 1900, his Plaza blacksmith shop, farm implements, wagon, and buggies sales were very much a product of the times. Just four years later and newly married, he was the proud owner of the first automobile in Ashland. His auto's enormous wooden wheels often got stuck in the middle of the unpaved Plaza's oozing mud.

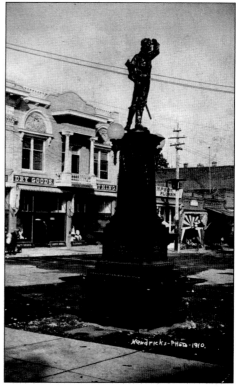

As the early generation of Ashland settlers passed on, several pieces of public art were purchased in their honor, including the pioneer man who has stood on the Plaza since 1910. This 15-foot-tall combination fountain and statue was a gift to the city from the children of Henry and Harriet Carter. Prominent citizens and activists, the Carters were involved in banking and orchards and gave the town Siskiyou Boulevard.

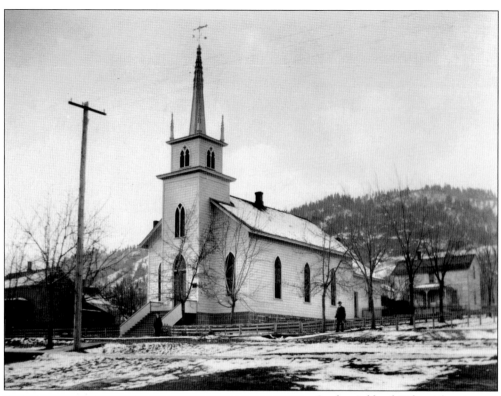

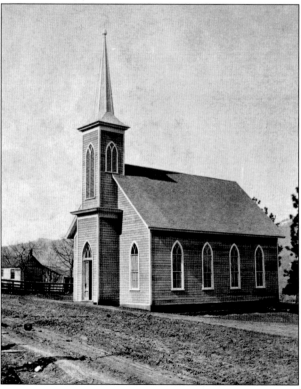

In the *Ashland Tidings'* first issue, published June 17, 1876, the editor opined: "There is no church, and no saloon, but whiskey is sold by the bottle and preaching is done in the schoolhouse; and therefore, the people are generally happy." Perhaps townspeople were initially satisfied meeting in homes and the schoolhouse with a circuit-rider minister, but Ashland's first permanent church buildings were constructed within two years of the editorial. The first church building was constructed in 1877 by Methodists at the corner of Main and Laurel Streets. This was followed by Presbyterians, who built the following year on a natural rise of land perched above the Plaza at Helman and North Main Streets. While the significantly remodeled Methodist building still stands, the Presbyterian church was replaced with a motel in the 1960s.

In addition to church buildings, a growing town needed a larger, more substantial schoolhouse. This South School was built on the corner of Gresham and East Main Streets in 1880 at a cost of $1,600. It consisted of four rooms. The two-story building was eventually moved and recycled as the Vendome Hotel.

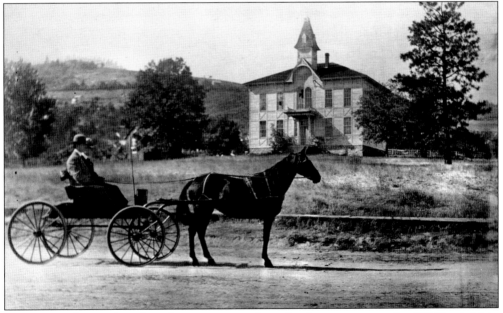

A few years after south-end needs were met, another school was constructed at 400 North Main Street, appropriately called the North School. Built in the mid-1880s, it was vacated in 1905 when a new brick building was erected a few blocks away at 200 North Main Street. The pictured structure stood empty for six years seriously deteriorating, until it was finally demolished.

27

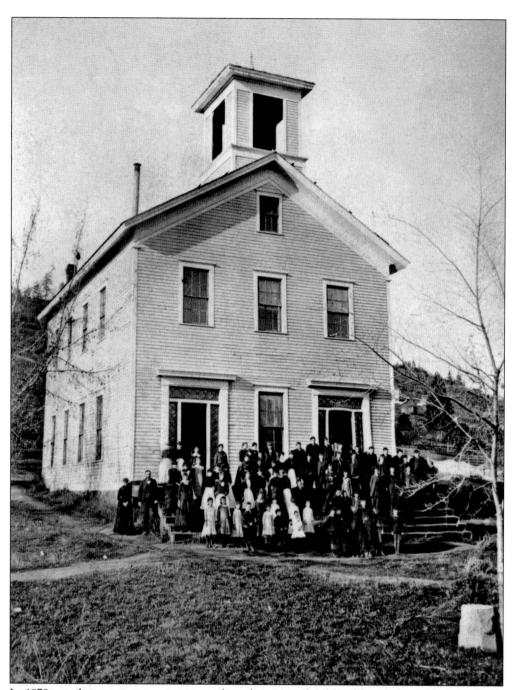

In 1879, a utilities company report regarding the town of Ashland listed the existence of "one college and Normal School." Begun in 1872 with 130 students, the term "college" might have been a stretch, and funding was always uncertain. The school lost funding and was forced to close by 1890. Nevertheless, the continued desire for an institution of higher learning eventually led to today's Southern Oregon University. Note the horse demounting stone (foreground, right) or the "uppin' block," as some referred to it, in reference to women climbing in and out of their carriages.

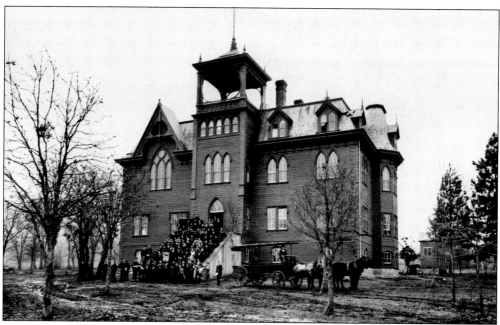

By 1895, the college had gained both status as an official state normal school and funds for a new building on Siskiyou Boulevard between Park Street and Hillview Drive. However, it was forced to close once again in 1909 when the Oregon State Legislature failed to fund normal schools after doing so for 10 years. Also pictured is the 1895 Normal School football team, likely the first since the second incarnation of the school. After closing its doors in 1909, these structures were dismantled with windows, trim, and other parts sold off to townspeople. Note the "school bus," which traveled between the Normal School and downtown.

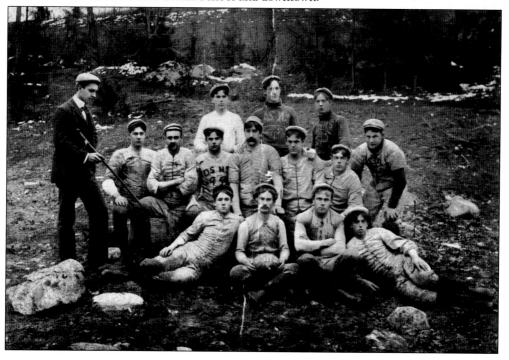

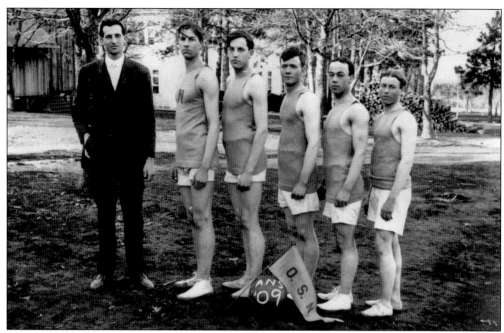

Shown on the grounds of the Ashland Normal School in 1909 is likely the last college basketball team until the Normal School was reestablished in 1926, once again in a new location. An eight-member faculty had been paid $200 a year for teaching, advising, and coaching, including Professor Wardrip, pictured here. With local donated community support, students were able to complete the year.

DO YOU KNOW THAT

¶ Oregon is the only state in the Union that ever reduced the number of its normal schools?

¶ Only five states in the Union have a smaller equipment for normals than Oregon would were all three of its schools running?

¶ Oregon's schools must find over 1,000 new teachers each year?

¶ Eighty per cent of the applicants for teachers' certificates in Oregon last year had received no training above the eighth grade?

¶ The Southern Oregon State Normal was successfully conducted for fourteen years until the legislature deadlocked over the regular appropriation?

¶ It has a plant ready to open up tomorrow, sufficient to meet all requirements for several years?

¶ Not one of Southern Oregon's counties has an educational institution to which the state contributes a dollar of support?

¶ To the average taxpayer of the state this school will mean less than two cents per year? To the man with property assessed at $4,000 it means the price of one cigar a year?

¶ This school is to train the trainers of your children?

Vote for the Southern Oregon State Normal School, General Election Nov. 3, 1914

ALUMNI ASSN., S. O. S. N. S.

This campaign piece was part of an unsuccessful attempt to regain funding for the Southern Oregon Normal School in 1914. Only because of a very aggressive lobbying effort by local representatives, a sympathetic governor, and an agreement by the town to provide the land did the 1925 state legislature once again agree to commit funds. (Courtesy of author's collection.)

Two

DRIVING A GOLDEN SPIKE IN ASHLAND!

Slow, steady growth characterized Ashland until the winter of 1887, when Southern Pacific's north-south line was joined. A celebratory golden spike marked the spot at the south end of the town's recently built rail yard. It was now possible to travel in an elongated circle of tracks around the entire United States. With Ashland strategically placed closest to the steep Siskiyou Pass, soon a depot, roundhouse, water tank, repair shop, and stockyard were in place.

Ashland's isolation and slow growth was over. A separate town seemed to be taking hold below the Plaza and stage road (Main Street) with its own energy, payroll, and mores. Restaurants, rooming houses, a grocery and drugstore, a butcher shop, a pool hall, and at least two brothels sprang up along with a fire station and jail near the depot. No doubt it was a lively place with trains coming and going throughout the day, all needing to stop to add or subtract engines before or after climbing the Siskiyou Pass. Visits from sitting American presidents became regular events, and local orchardists and ranchers had new expansive markets never dreamed of before, including other parts of the country and even Europe.

However, those favoring temperance and the values of education and piety that were preached up the hill at the Chautauqua tabernacle each July were confronted with a new coarseness "below the boulevard" they could only warn their children about. Railroad yards always seemed to attract what was perceived as an underclass. Muggings at the depot and open physical confrontations between union men and others, coupled with ethnically different gangs of foreign workers, could be affronts to small-town sensibilities.

Always a difficult climb over the Siskiyou grade, Southern Pacific opened a new, more cost-effective route between 1926 and 1927 by routing rail traffic to the east through Klamath Falls, bypassing Ashland. While a skeletal operation remained, 40 years of prosperity and arguably, diversity, were over. Businesses lost customers, rooming houses lost renters, and numerous properties could be purchased for back taxes. Even the small Chinese population, who labored and lived near the railroad right-of-way, moved on.

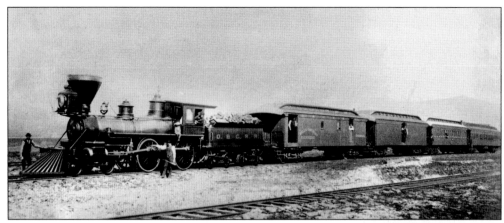

The first regular passenger train engine of the Oregon and California line from Portland into Ashland is pictured in May 1884. Engineer D. McCarthy is holding an oil can, and fireman James Porter is at the front of the engine. The engineer's son, H. G. McCarthy, is sitting on the running board. The man in the cab is Ashland engine-wiper Joe Marshall.

Three years after the May 4, 1884, event, Southern Pacific bought out the remaining interests of the Oregon and California line, including the Oregon and California engine pictured above at the Ashland depot.

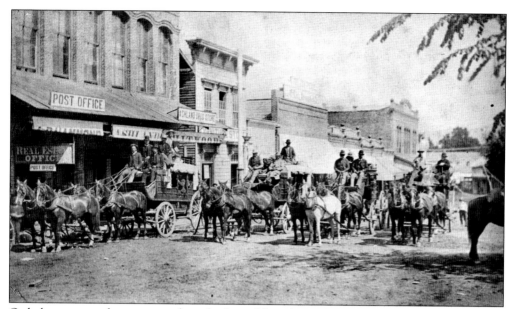

Only by stagecoach, wagon, or horseback could mail, goods, and individuals move over the steep 4,000-foot Siskiyou Mountains before completion of a north-south railroad route. Remote locations and slow movement made stage robberies legendary, including those of highwayman Black Bart. With completion of the rail system through Ashland in 1887, the focus of daily town activity shifted to Fourth Street.

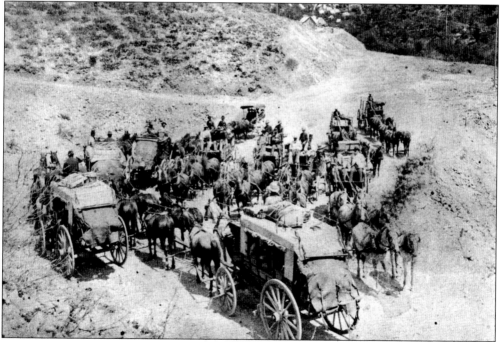

These coaches are headed toward Ashland as people are transferred from the California end of the railroad line to the Oregon end in mid-1887 before completion of the north-south rail route. Note the construction camp in the center distance. The road where the coaches are changing passengers became the railroad bed, with tracks being laid that summer and fall.

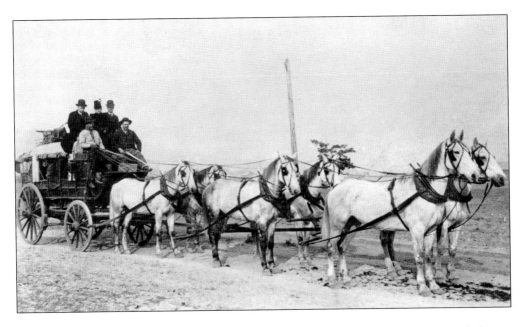

Because of the steep grade over the Siskiyou Mountains, additional horses were needed prior to the railroad to pull freight wagons and stages. Later, in similar fashion, extra engines were attached to trains coming and going over the mountains. It typically took six horses or three engines to make the grade. Ashland, because of its strategic location at the base of the mountains, consequently became a division headquarters. The Southern Pacific needed a train yard complete with roundhouse where engines could be added or subtracted. The railroad purchased land that had been a previous Donation Land Claim owned by two of Ashland's earliest settlers, first by Robert Hargadine and later by Lindsay Applegate.

S.P. Train Leaving Ashland.

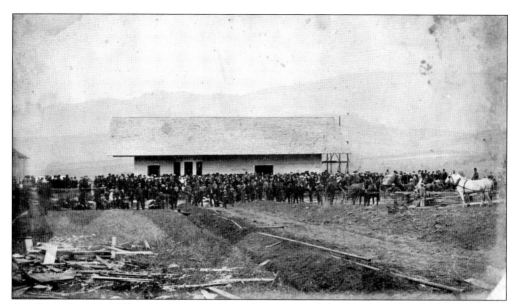

On December 17, 1887, a symbolic golden spike was struck by Southern Pacific Railroad vice president Charles Crocker at the Ashland rail yard. Oregon and California were now joined, or as the arch straddling the tracks read, "Welcome to Oregon and California—Linked at Last." The coming of the railroad to Ashland meant significant change, a point not lost on a crowd estimated at 1,200, who cheered wildly, ignoring a bitterly cold, foggy evening.

A new required skill set accompanied the change from stagecoach and wagon driver to railroad engineer. Caught in the transition was Ashland stage driver Henry Giddings, in 1887, with the completion of the north-south railroad route into California. Giddings took up driving the road over the coastal mountains to Crescent City, California, to stay employed.

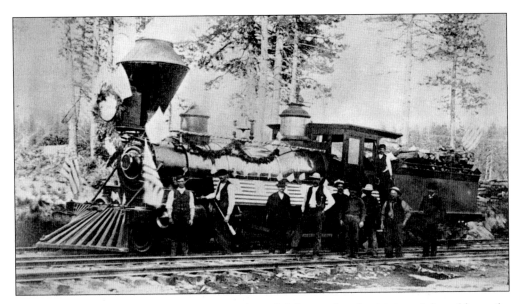

The first regularly scheduled passenger train from California after the driving of the golden spike on December 17, 1887, is pictured here. It arrived in Ashland on the following day, December 18. Continuing its northern route after an Ashland stop, the flags and decorations are in celebration of this line connecting California and Oregon. Symbolically, this train was nationally significant because it reflected a complete railroad circle around the United States. Now local products such as cattle, hogs, wool, fruit, and grain could reach markets outside of the local valley.

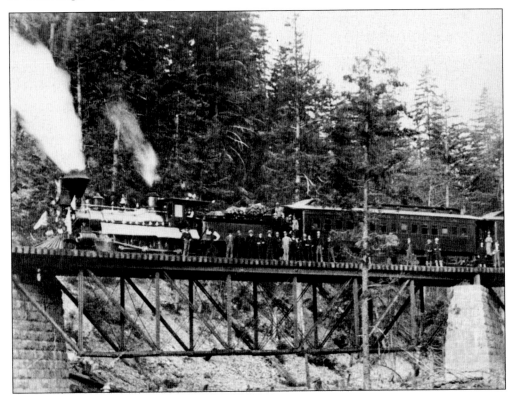

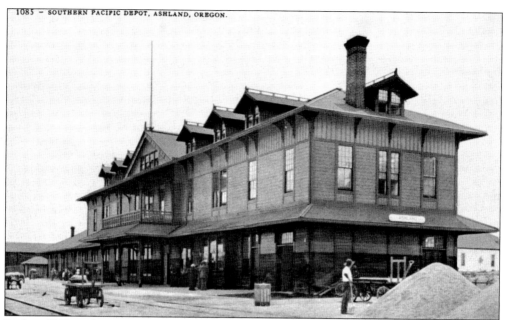

Built in 1888, within a year after the connection of Southern Pacific's San Francisco and Portland lines at Ashland, this huge three-story Victorian depot was the site of great excitement as daily trains arrived and departed. Horse-drawn coaches queued up to transport passengers, and real estate salesmen mingled in the crowd showing visitors brochures in an effort to entice them to buy a small orchard or farm.

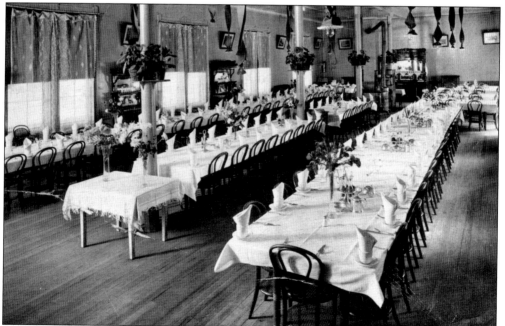

As each train arrived, loud noises punctuated the air, including the clang of a triangle announcing meals available in the dining room. Up to 200 passengers could be served in the depot dining room, and while tables were elegantly set with white linens, guests only had 20 minutes to eat. It was a prompt, 30-minute layover.

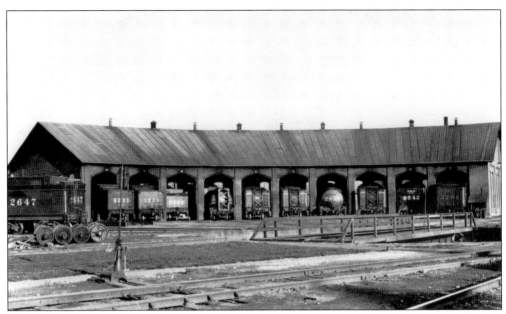

Initially, Ashland had an even busier rail yard with more equipment and men than most division points would have because of the steep mountain terrain. A 10-bay, brick-lined roundhouse served until the end of the steam engine era. Southern Pacific dismantled the giant brick roundhouse but continued to use the turntable for many years even with a much reduced operation.

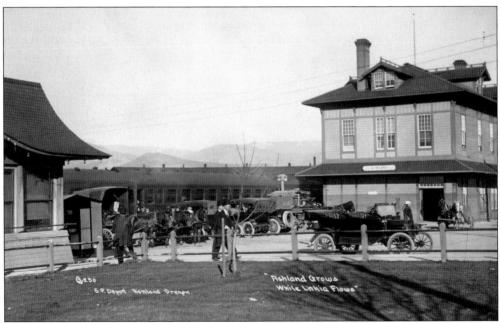

Note the town slogan promoting its lithia water in the foreground. In addition to Lithia Park, a lithia water fountain was located just north of the depot so passengers might sample its many benefits. At left is the exhibit hall where local produce was featured. Ashland boosters never missed an opportunity to entice their railroad visitors.

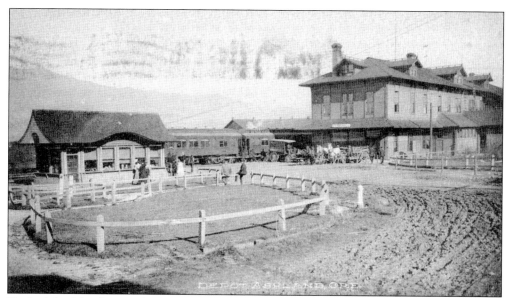

To the left of the depot is the permanent exhibit center where area farmers and orchardists could show their agricultural products to the constant stream of visitors during 30-minute train stops. In front was a cattle corral, which was greatly enlarged over time. The Southern Pacific depot/hotel featured 40 sleeping rooms.

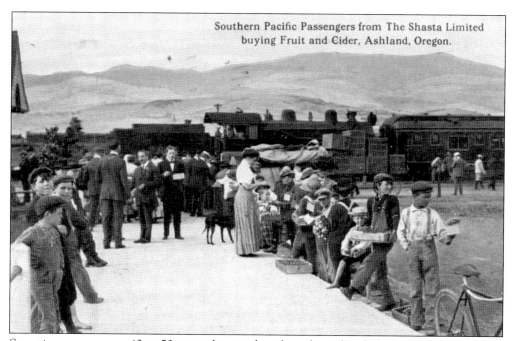

Sometimes as many as 40 to 50 young boys gathered on the railroad platform hawking baskets of peaches and berries. It was a noisy place, with each young man trying to drown out the voices of the others. Southern Pacific became concerned about the behavior of some boys because they jumped on cars while the trains were still moving. By 1915, Southern Pacific wanted all selling by children prohibited.

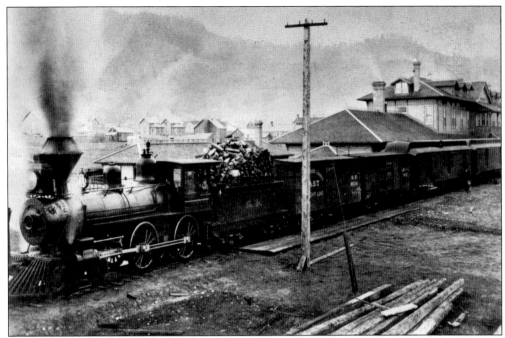

Once Ashland was connected by rail to California, its population more than doubled from 842 residents in 1880 to 1,784 in 1890 according to the United States Census Bureau. Note the source of fuel is huge amounts of wood for this Southern Pacific engine.

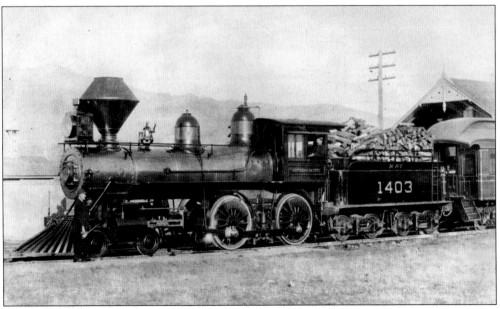

Brakemen, firemen, engineers, and conductors took up residence in the new railroad addition as lots were sold and houses were built on A, B, and C Streets and along Fourth Street. It was the job of "call boys" to run from house to house and pound on doors to awaken the key railroad men an hour and a half before train time.

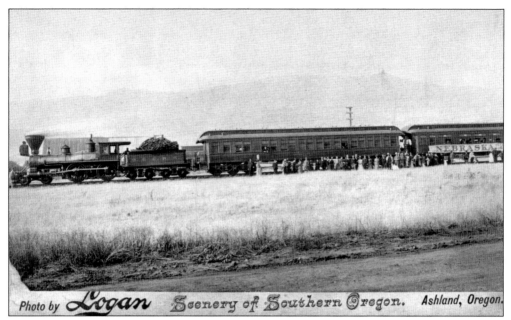

Photo by *Logan* — Scenery of Southern Oregon. Ashland, Oregon.

Both passenger and freight trains stopped in Ashland, up to five trains each way a day! Compared to stages, train travel was like "traveling by telegraph," according to the *Ashland Tidings*. The first passenger train came to Ashland loaded with cheering local folks who had gone a few miles north so they could experience their first train ride. The 157-acre railroad addition nearly doubled the physical size of Ashland.

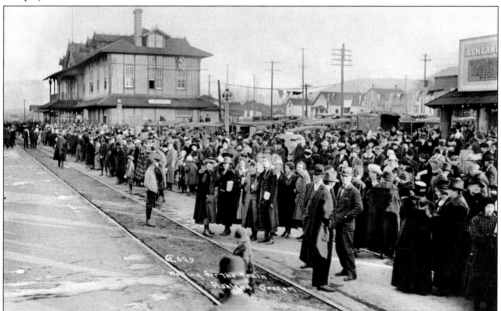

The railroad district was an exciting place! Troop trains coming through added patriotic interest and meant flags flying, with food, fruit, candy, flowers, and meals prepared for servicemen. Restaurants and hotels hired young boys to work as "curb runners," encouraging passengers to frequent their businesses, with some hawkers becoming so aggressive that they became known as the "Bad Boys of Ashland."

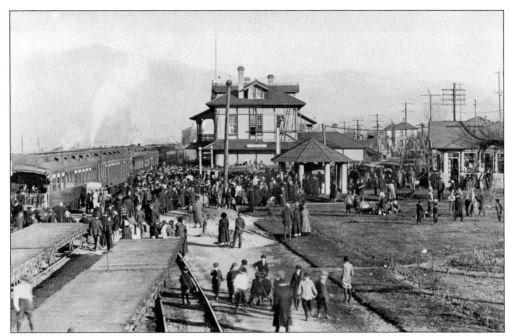

With trains coming and going, all that noise and congestion on Fourth Street just above the depot drew children who were attracted to the activity compared to the rather predictable and safe life above Main Street. Chinese railroad workers, who spoke little English, dressed differently, had their own customs, celebrations, and items for sale, and could be found near Second and A Streets, providing fascinating diversity for Ashland's young.

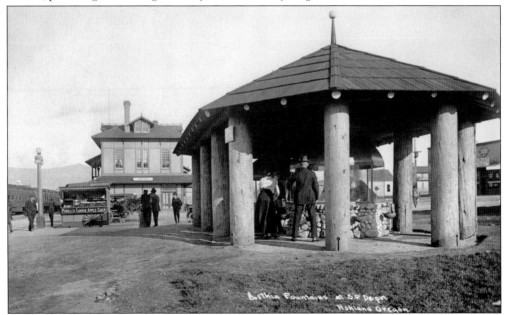

Two major attractions for train travelers stopping in Ashland were locally grown apples pressed into cider and a kiosk of lithia water located near the depot. Enterprising young men provided recycled paper cups to drink from for a nickel. Albert Powell, known as the "Ciderman," grew apples near his home on A Street.

A large influx of railroad workers resulted in an acute housing shortage and a consequential building boom as the railroad assigned increased numbers to the Ashland yard. Southern Pacific made lots available for homes, and they sold rapidly as families purchased land for new homes such as this one on B Street. Some workers even speculated, buying adjacent lots for a rental house or just to hold.

An enormous arch, tall enough at 34 feet to clear a locomotive, spanned the main track to welcome Theodore Roosevelt aboard the "Presidential Special" to Ashland. Buildings were decked out in red, white, and blue, and a cannon located on Chautauqua Butte (site of the current Elizabethan Theatre) was prepared to fire a salute as Roosevelt's train pulled in.

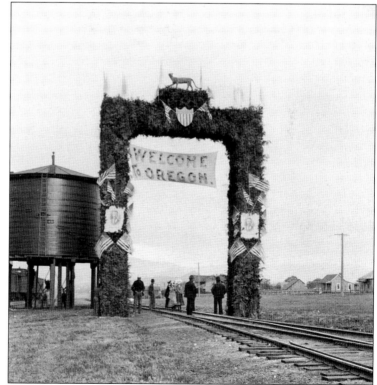

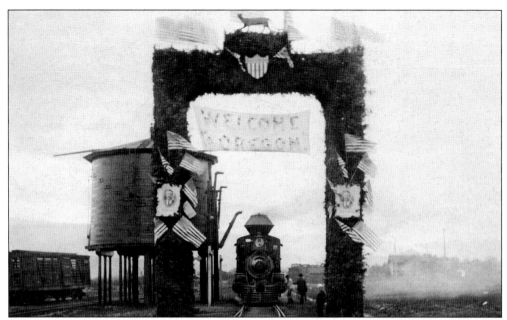

Until this 1903 photograph surfaced in 2008 along with a companion picture of Theodore Roosevelt speaking from his train car in Ashland, accounts of the welcoming arch crashing to the ground before the arrival of the president's train were common. There is evidence that an arch across the tracks to welcome Spanish-American War veterans a few years earlier did collapse, and the two arched events may have been confused. (Courtesy of author's collection.)

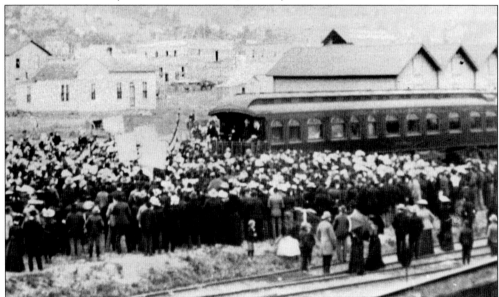

The 1903 Theodore Roosevelt visit was organized with school children, college students, Civil War veterans, and national guardsmen getting the best spots closest to the train platform. Roosevelt specifically addressed the Civil War veterans, complimenting them for their courage, which held the Union together. Raucous hurrahs accompanied each Roosevelt comment. With the train slowly pulling away, the town band struck up "America," and the huge crowd sang from printed sheets.

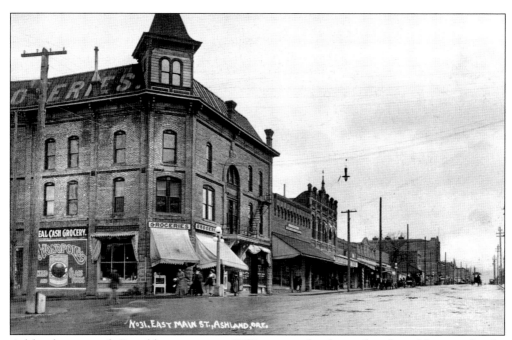

Ashland, a staunch Republican town in 1903, prepared a day and night celebration for the president's visit. Even with Roosevelt well on his way north, the celebration would continue. That evening at the Ganiard Opera House, pictured here, 125 couples attended a special presidential ball that continued well into the early morning.

A business district developed along Fourth Street and the south side of A Street to serve the rapidly growing railroad addition. Pictured in the background of this 1899 photograph is a newly constructed grocery at the corner of Fourth and A Streets. Lodging houses for the influx of single men, saloons, restaurants, warehouses, and at least one well-documented brothel existed.

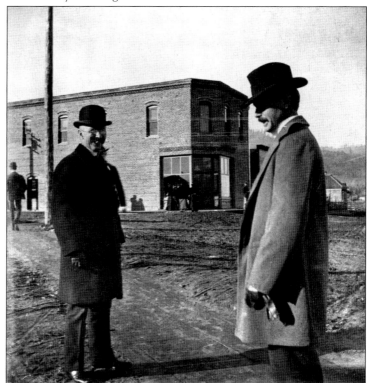

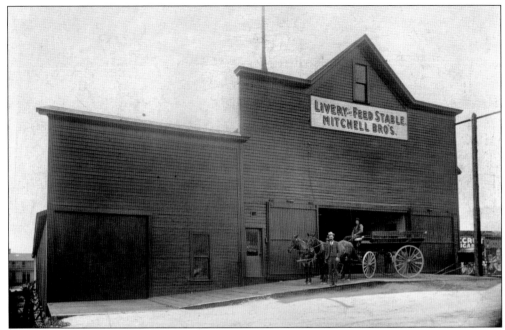

This livery and feed store next to the Fourth Street fire station played an important role, because the city firefighters did not own any horses and would need to borrow them when there was a fire. If the livery stable didn't have any horses available to use, the firemen would have to pull the fire wagon themselves!

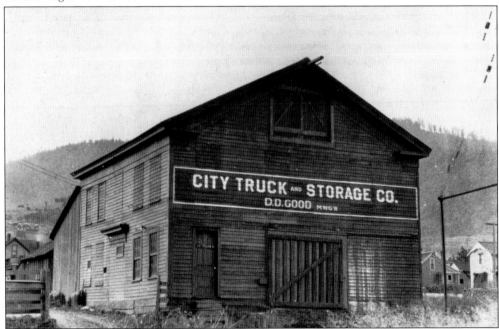

Pictured here as City Truck and Storage Company, the former Plaza road house called Ashland House was moved first to the back of the buildings fronting Main Street in 1889 and then about 1913 to A Street between Second and Third Streets in the railroad district. Obviously converted to other uses, it was finally torn down in 1960 for a parking lot.

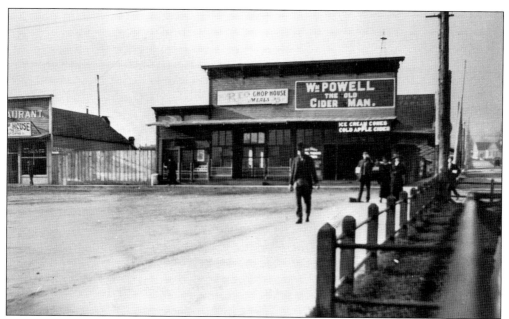

Eating establishments lined A Street near the depot. On the left is the Van Sant building, which served as a restaurant named the Palace Chop House in this c. 1908 photograph. Centered in the picture is Reo Chop House, and on the right is William Powell's confectionery shop. William Powell's daughter presented president Benjamin Harrison locally grown fruit upon the president's arrival by train in 1891. Powell had served in General Harrison's Civil War division.

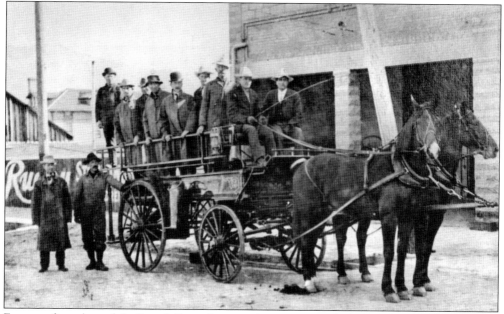

Frequent fires plagued the Fourth Street business district, especially between 1898 and 1903. After the 1903 blaze resulted in the destruction of several wood-frame buildings, the city required that all new building in the area be of brick or stone. Another improvement came in 1908, when hand-drawn hose carts were replaced with a fire wagon pulled by rented horses, proudly being shown here in front of the Fourth Street fire station.

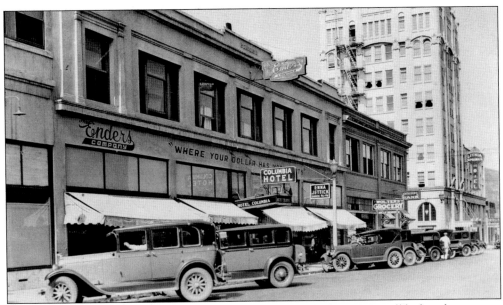

Henry Enders ran a shopping mall that stretched for a full block in 1912, well before the concept of attached stores became common. It was possible to go in one door and pass through several stores with interior archways. It was the largest floor space between Portland and Sacramento, with 32 employees serving customers in its many departments. The store slogan was "Where your dollar has more cents." Wah Chung, pictured here with his family, was the Chinese labor crew boss for Southern Pacific Railroad and a regular customer at the Enders Store, as he did all of the shopping for his 20–30 live-in Chinese laborers. His mail-order bride became a curiosity with her tiny bound feet, which made walking difficult for her. Enders was able to special order shoes for her after one of his employees took careful measurement of her feet.

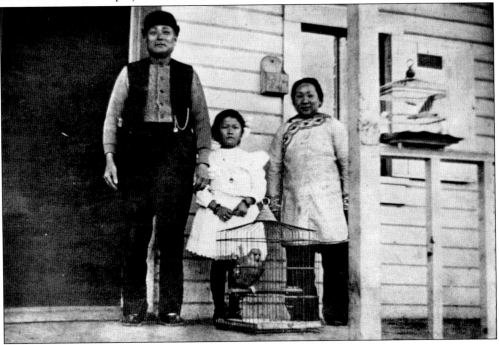

Kindly Post in a Conspicuous Place

$15,900 REWARD IN GOLD!

$5,300 Reward For Each Man

United States of America
POST OFFICE DEPARTMENT

ON OCTOBER 11, 1923, A SOUTHERN PACIFIC RAILWAY TRAIN WAS BLOWN UP NEAR SISKIYOU, OREGON, U. S. A. THE MAIL CLERK WAS KILLED AND HIS BODY BURNED, AND THREE TRAINMEN WERE SHOT AND KILLED. CONCLUSIVE EVIDENCE OBTAINED SHOWS THAT ROY, RAY AND HUGH DE AUTREMONT, THREE BROTHERS, WHO LIVED IN EUGENE, OREGON, COMMITTED THE CRIME. THEIR PHOTOGRAPHS AND GENERAL DESCRIPTIONS ARE SHOWN ON THIS POSTER.

Help in locating the criminals who committed this terrible crime.

REWARDS TOTALING $15,900 WILL BE PAID FOR INFORMATION LEADING TO THE ARREST AND CONVICTION OF THESE MEN. THE UNITED STATES OFFICERS HAVE CONCLUSIVE EVIDENCE AND WILL TAKE CARE OF THE PROSECUTION.

ANY INFORMATION CONCERNING THE WHEREABOUTS OF THESE MEN SHOULD BE COMMUNICATED IMMEDIATELY TO THE NEAREST POLICE OFFICER. IF CONVINCED THE SUSPECTS ARE THE MEN WANTED NOTIFY THE PERSONS NAMED BELOW BY WIRE.

ROY A. A. DE AUTREMONT.

RAY CHARLES DE AUTREMONT.

HUGH DE AUTREMONT.

SIGNATURES OF THE MEN:

Roy Harris.
Specimen of Handwriting of Roy DeAutremont.

Wm Elliott.
Specimen of Handwriting of Ray DeAutremont.

E. E. Jones.
Specimen of Handwriting of Hugh DeAutremont.

$15,900.00 REWARD
IN GOLD

Train Hold-up and Murder

MAIL CAR AFTER HOLDUP.
Where the postal clerk was cremated.

$15,900.00 Reward in Gold!

$15,900.00 REWARD
UNITED STATES
Post Office Department

Read this Story of a Terrible Crime

Train Hold-up and Murder
— OF —
Three Trainmen and a Mail Clerk in Siskiyou Mountains of Oregon.

$15,900.00 Reward in Gold!

No. 13 Printed July 23, 1926. Two hundred sixty thousand copies, 8670.90.

The last train robbery in the West occurred after leaving the Ashland yard on October 11, 1923, resulting in the death of Ashland resident Elvyn Dougherty, a railway postal clerk. Three men from other towns were also murdered, including the engineer, fireman, and brakeman at Tunnel 13 in the Siskiyou Mountains. In addition to the senseless taking of life, it was all in vain since the three DeAutremont brothers did not get any money. Hugh, Ray, and Roy, totally inexperienced in the use of explosives, blew the mail car completely apart thinking that $40,000 was on board. The explosion killed Dougherty while the other three railroad men were systematically gunned down. The brothers became the focus of a massive international manhunt over a four-year period. Hugh was finally discovered serving with the U.S. Army stationed in the Philippines. Ray and Roy were captured in Ohio, where Ray had married and fathered a son. This wanted poster and others printed in several languages helped in the eventual capture and imprisonment of the three brothers.

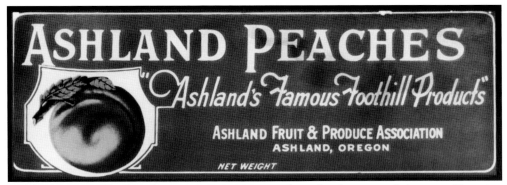

Ashland Fruit and Produce Association, a cooperative for orchardists, provided a central location for shipping their perishable goods to new markets. Fruit was graded, packed, and shipped by rail under one name, with much of it sent to San Francisco. The site later became home to Oak Street Tank and Steel Company and currently houses a variety of businesses and a theater group.

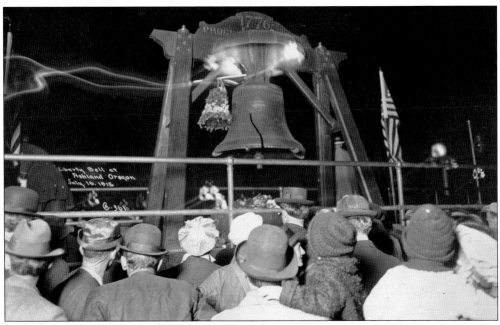

From 1885 to 1915, the Liberty Bell traveled by train to numerous cities and was displayed at expositions and world fairs. In 1902, it was involved in a train wreck, but the practice continued. In 1915, it took its last nation-wide tour while returning from the Panama-Pacific International Exposition in San Francisco. By the 1930s, it was determined that moving the bell about the country was too risky, and the practice ended.

Three

A CULTURAL MECCA?

Beginning in 1874 in New York State at Lake Chautauqua, Methodist Sunday school teachers gathered for edification. By the 1890s, a circuit of summer Chautauquas providing adult education multiplied nationwide, especially in rural America. Communities vied for the opportunity to bring the 10-day events consisting of sermons, lectures, and music to their citizens. By 1924, Chautauqua assemblies numbered more than 10,000 and were drawing an estimated audience of 30 million!

In 1893, Ashland was the largest population center in Southern Oregon, but a Methodist campground already existed in Central Point, and initially this seemed the logical location for a Chautauqua assembly. It took the persuasive personal intervention of Ashland booster G. F. Billings to locate the Chautauqua on the hillside above the flour mill. The site had been previously rejected as a location for the Normal School. Almost giddy in its endorsement of the selection, the local paper referred to Ashland's "resources, pluck, enterprise, and intelligence."

Certainly enterprise was evident, as a beehive-looking structure was constructed in 10 days, exactly one day before its first session opened on July 5, 1893. In order to increase seating capacity during its more than 30-year run in Ashland, the structure was rebuilt two more times, significantly changing its shape each time. "Talent," as presenters were called, included visits to Ashland's assemblies by William Jennings Bryan, Billy Sunday, John Philip Sousa and his band, Booker T. Washington, William Howard Taft, and Joaquin Miller, "The Poet of the Sierras."

While Chautauqua brought entertainment and enlightenment, there is no clear evidence that a more inclusive society resulted. At the peak of Ashland's Chautauqua attendance in the 1920s, its Fourth of July parade included over 100 fully robed members of the local Ku Klux Klan. Disputes over temperance and saloons had been on-going, and the local Commercial Club's promotional pamphlet advertised Ashland as a desirable place to live because of "the absence of negroes and Japanese." Ashland, it seems, continued to look and act as most small towns across America did, like the fictional hometown of Sinclair Lewis's George Babbitt.

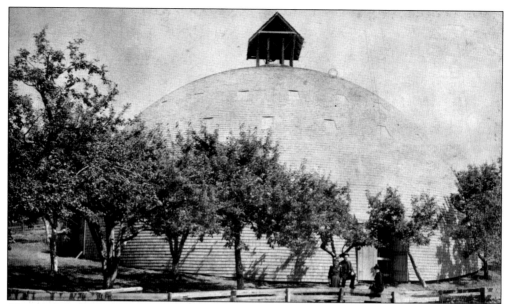

Chautauqua was a national traveling program of lectures and entertainment that brought culture and educational opportunities to rural America. These summer events were held in three different wood-domed tabernacles during Chautauqua's more than 30-year run in Ashland. Bonds were issued for $4,000 to acquire acreage and build a structure large enough to hold 1,000 Chautauqua attendees. Because of the national economic depression of 1893, though, banks would not loan money, so private funds had to be secured. The building, looking like a giant beehive, had no interior posts or pillars supporting the roof. It was 40 feet high and 80 feet in diameter, and there are oral accounts of some so unsure of its safety that they waited a session or two before attending. Pictured are the first domed tabernacle and the same building with a new cupola by 1900.

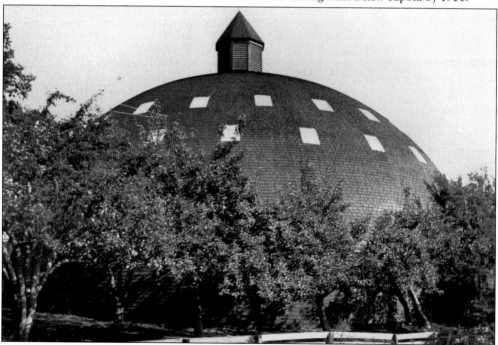

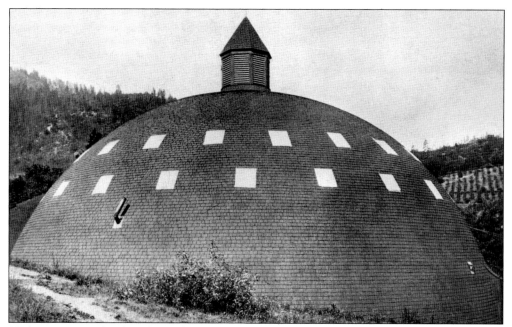

Within 20 years of its founding, what started around a lake in New York State had happily spread all the way to Southern Oregon. This structure was located on the current site of the Shakespeare festival's outdoor Elizabethan theater. Completed on July 4, 1893, by a 40-man crew in somewhere between 5 and 10 days, the first assembly was held on July 5, 1893. Obviously construction impediments were nonexistent.

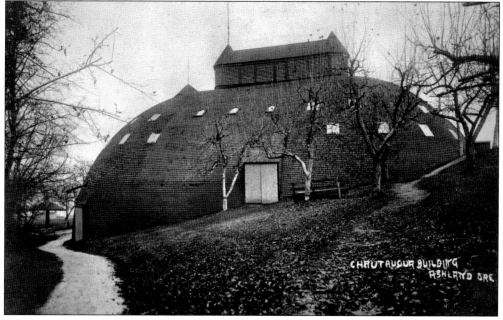

After turning people away for several years, it was decided to cut the original 1,000-seat building in half and add a new section, which would double the seating capacity to 2,000. The building was rebuilt and in place for the 1905 season. This elongated structure would serve until it, too, needed enlargement by 1917.

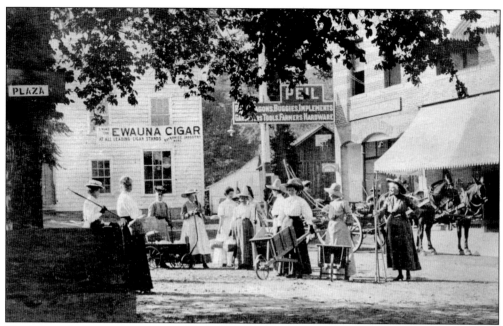

The Women's Civic Improvement Club had a proud history as major reform leaders in Ashland even before gaining the benefit of suffrage for themselves. The smell and unkempt look of the abandoned flour mill had become an uninviting entrance to Chautauqua. Clean-up work parties could only do so much to improve the landscape. Women forced a 1908 vote setting aside the old mill site and city property which bordered the creek as park land. Despite opposition from businessmen who thought the land better suited for stores, and some voices from those who favored preservation of the historic 1854 mill, the public vote was overwhelmingly in favor of a park. This would not be the last time open space and historic preservation would become town issues. With the mill gone, a more tourist friendly, if less historic, approach greeted Chautauqua visitors.

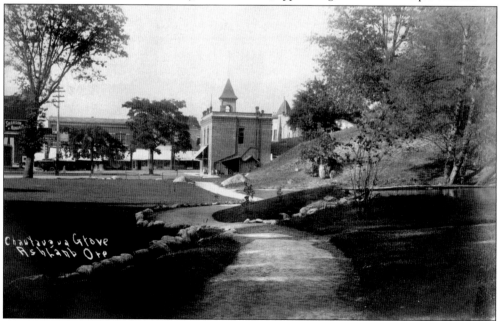

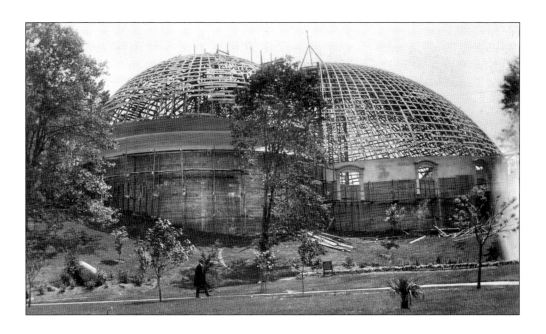

A dozen years after the 1905 expansion, once again significant numbers of people were unable to be seated. In 1917, $15,000 in bonds were issued to acquire more land and build a completely new Chautauqua building featuring two domes constructed above a concrete foundation wall. This new structure was built to accommodate up to 5,000, including those seated and on stage. The huge stage was complete with dressing rooms and restrooms below. In order to complete the project on time, stores were closed, and town men and boys with hammers were pressed into action to finish the job.

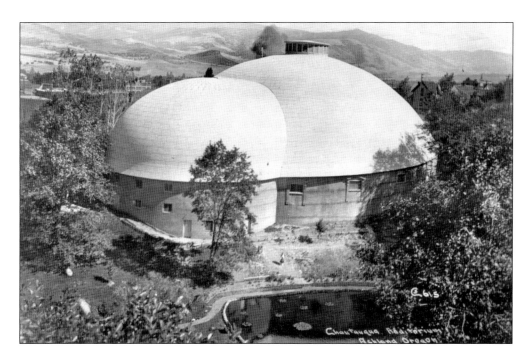

With a self-supporting roof 160 feet in diameter, the newly constructed 1917 auditorium was something of an architectural wonder. Built without pillars, trusses, or steel, the roof was entirely made of wood. Strips of wood were nailed to each other and the rafters over rib work, creating a solid shell. Asbestos roofing was laid over the sheeting to waterproof it.

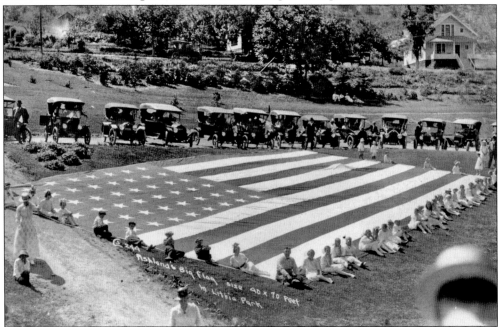

Despite officials' claims of excellent acoustics, an annoying echo effect inside the new cavernous Chautauqua building led to the purchase of this enormous 40-by-70-foot flag hung from the roof in hopes it would improve the situation. While not a successful remedy, it became an attraction in its own right. The bump right of center is a playful child who could not resist crawling under it.

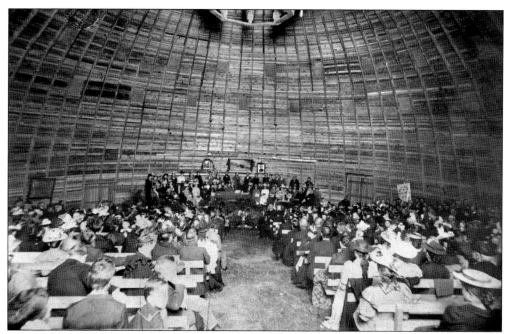

Interior photographs of any of the three Chautauqua buildings are somewhat rare. This photograph shows a grass and dirt floor, which is usually attributed to the first structure. Some have identified this particular photograph as a Women's Temperance Meeting in 1893. The Temperance movement was very strong and successful in keeping saloons out of Ashland until the coming of the railroad.

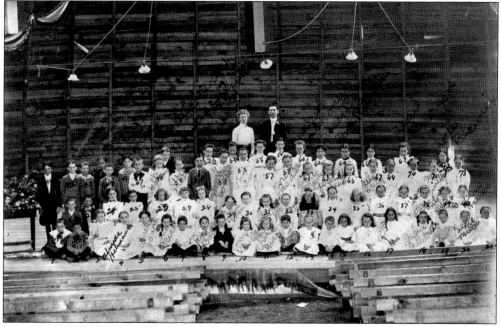

Chautauqua choirs were popular and an opportunity for summer music instruction. Pictured fourth from the left in the front row is Almeda Helman, granddaughter of town founder Abel Helman. Acoustically, there were no complaints about the first two buildings. In fact, most praised how well the beehive-shaped shingled structures provided an effective venue for musical events.

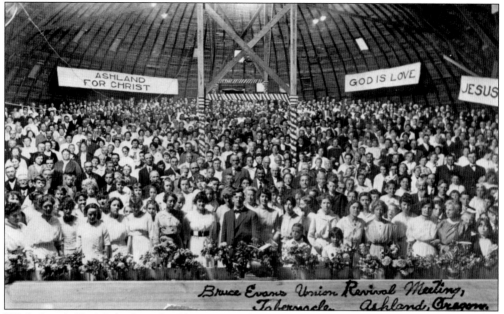

Bruce Evans Union Revival Meeting, Tabernacle. Ashland, Oregon.

While founded by Methodists, the Chautauqua religious experience was mostly nondenominational, yet fundamentalism became the context of sermons and lectures, as can be seen in these banners. Revival meetings were well attended, and enterprising town boys would often find nickels and pennies scattered throughout the sawdust floor the morning after a major session.

Southern Oregon Chautauqua Association

SERIES "O"
No.

This Certifies That C. A. Simons

having paid the sum of Twenty-five Dollars, at his request, this fully paid Life Membership in this Association is issued to Mrs. C. A. Simons

Ashland, Oregon, July 21, 190 5.

President. NOT TRANSFERABLE Secretary.

There was a conscious effort to keep Chautauqua attendance affordable. Season tickets were $1 in 1893 and eventually cost $2.50 in the 1920s, but one could attend single performances for a quarter. Sundays were free with the understanding that an offering plate would be passed. Some Ashland supporters bought life memberships for $25 such as the one shown here. (Courtesy of author's collection.)

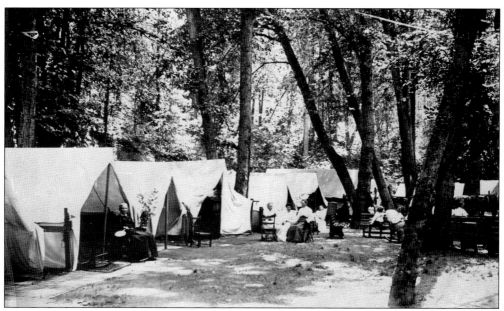

They came in wagons, pitched their tents in Chautauqua Park, and checked their horses at a nearby livery stable. Folks from Roseburg to Northern California were settling in for 10 days of Chautauqua events. Locals joined the excitement, sometimes renting tents themselves so they might see old friends, meet new visitors, and just be a part of it all. Chautauqua Park became a campground for up to two weeks each July even before an auto camp was created further up in the renamed and expanded Lithia Park. Meals were cooked, horses tended to, children played in the creek jumping from rock to rock, and each day brought classes in the morning and entertainment in the evening.

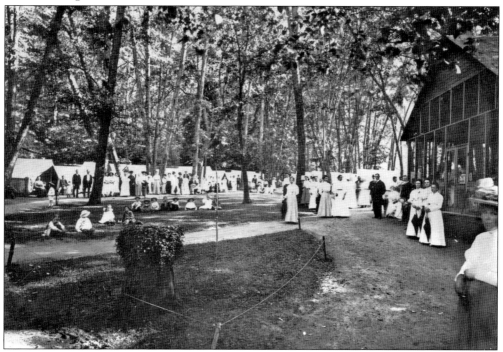

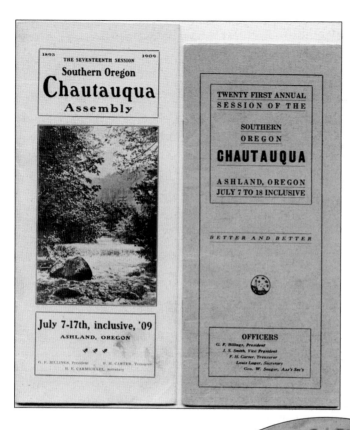

Each year brochures were produced in advance advertising who was coming that season. Orator William Jennings Bryan, opera singer Madame Schumann-Heink, former baseball player turned evangelist Billy Sunday, and John Philip Sousa and his Marine Band all entertained Ashland audiences. Madame Schumann-Heink's performance nearly bankrupted the local Chautauqua because she invited all of the local school children to her concert for free after children had sprinkled flower petals where she walked.

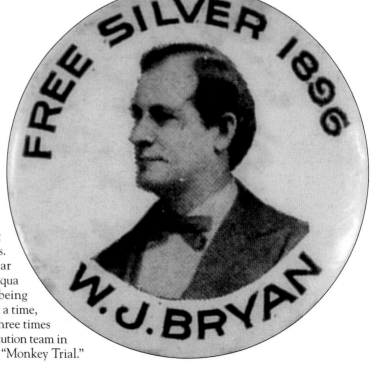

When William Jennings Bryan came to speak on the virtues of backing paper money with both gold and silver, he drew such a large crowd that he had to speak outdoors. The single most popular speaker on the Chautauqua circuit and famous for being able to speak for hours at a time, Bryan ran for president three times and was part of the prosecution team in the famous John Scopes "Monkey Trial."

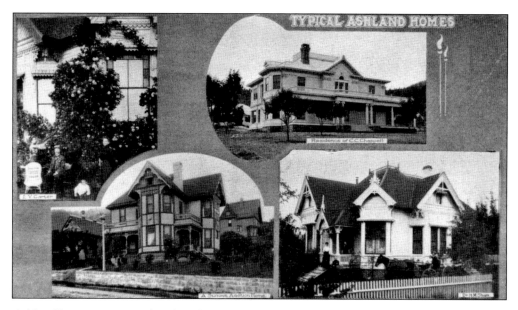

Ashland boosters in 1912 played up the cultural aspects of a town that had hosted Chautauqua for 20 years. It is doubtful whether the pictured residences were typical of the town, yet they are all grand examples of the era. Nevertheless, by 1912, Ashland did have a new high school, 14 churches available to its 6,000 residents, and a new, if controversial, Carnegie Library. Some had spoken out against enshrining industrialist Andrew Carnegie's name, and then there was the dispute of where to locate it. Support for placing it near the entrance to Lithia Park or at Gresham Street and Siskiyou Boulevard seemed to be most favored. A vote of the people ended the debate, and the city council paid for the overrun in building costs beyond the $15,000 provided by Carnegie.

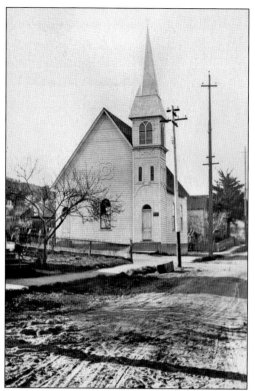

Churches play important cultural roles, and Baptist and Catholic churches were among the numerous ones residents could choose from. Both built in the 1880s, the two parishes are shown around 1900. This original Baptist church building stood at the corner of High and Church Streets, although the original street name, Church Street, comes from another church group that decided not to build on its property. Part of a building boom in the railroad district, the Church of the Holy Rosary was a Catholic parish at Sixth and C Streets. It served its congregation until 1959, when a new building was constructed in the southern part of the city.

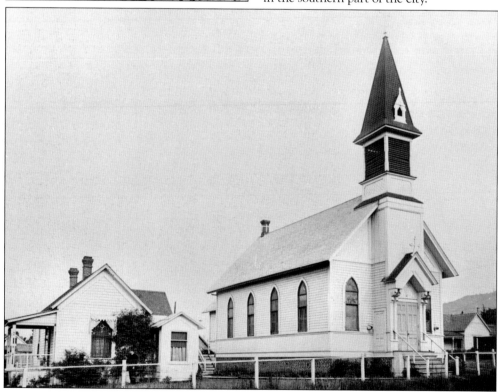

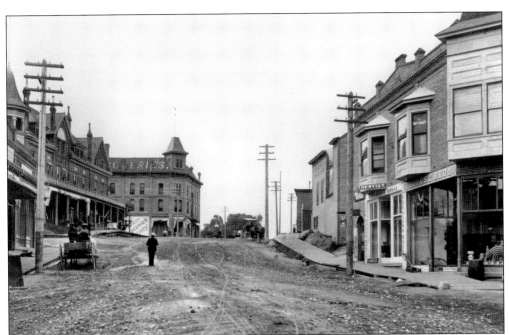

By 1900, Ashlanders could look up Main Street with pride and see the recently built Hotel Oregon and the multipurpose Ganiard Opera House just down the hill from Chautauqua Butte. If looking for "Sunday best" clothing to wear to the tabernacle, Vaupel, Beebe, and Kinney dry goods store, pictured on the Plaza around 1909, offered clothing for men and women. Corsets, hosiery, shoes, hats, and boots occupied one window display, while the other side featured hats, boots, shoes, and shirts and collars for men. Note cement sidewalks in place just before Plaza paving. Later, Perrine's outfitted residents in the same location for 60 years.

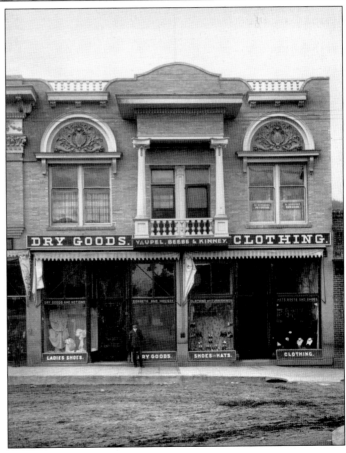

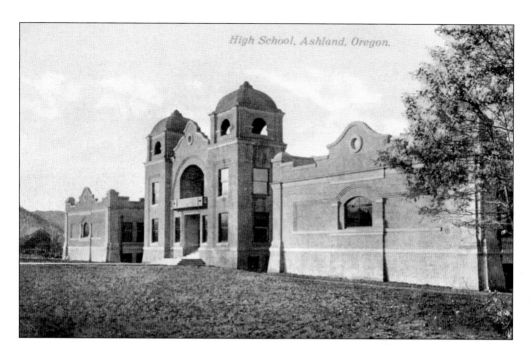

Adding to booster pride in 1911 was a new high school built on 8 acres of land between Morse and Mountain Avenues. In some ways it was an odd-looking series of buildings because of its Spanish Mission architecture, more often identified with California than Oregon. A main assembly hall could seat 400 students and contained the school library. A gym, which much expanded athletic programs, and a little theater were contained in the basement. Pictured above is the school just after construction and ready for occupancy, while the photograph below shows the popular look of letting ivy grow over the buildings 15 years later.

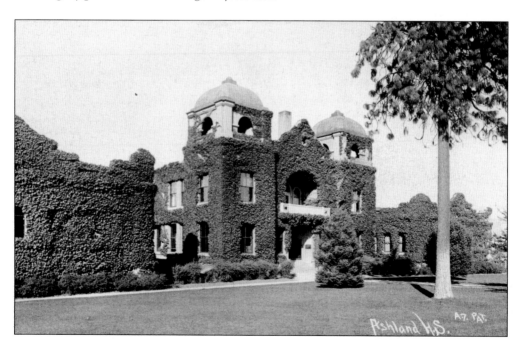

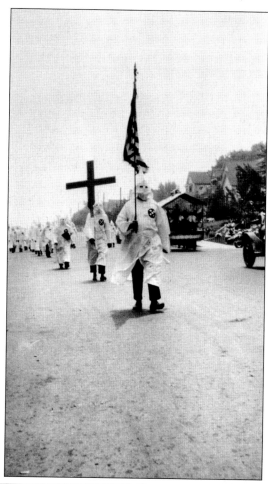

Ku Klux Klan activity in the 1920s was typical throughout small-town America. Initially active in the Southern states after the Civil War, by the 1920s, Klan focus had mainly shifted to an anti-immigration and anti-Catholic emphasis, finding acceptance in most states. Oregon towns may have been particularly susceptible to a non-inclusive philosophy because the state constitution, written in 1859, had long prohibited people of color from moving into the state, and Oregon did not amend its constitution to strike out this article until 1927. Nearby Medford was the first town in the state with an organized KKK chapter in 1921. It was quickly followed by Ashland, Grants Pass, and Klamath Falls in Southern Oregon. Pictured is a march by over 100 Klansmen in Ashland's July 4, 1921, parade.

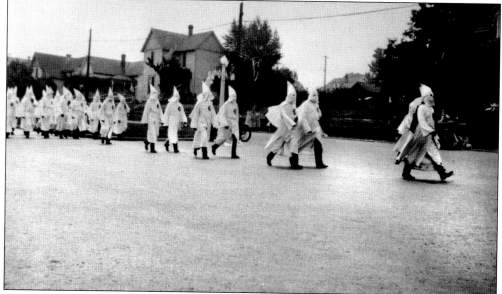

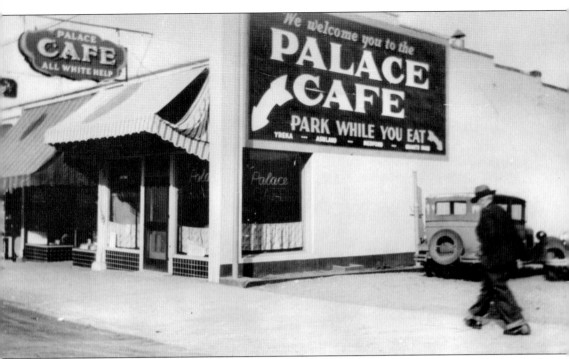

A residual bias toward ethnicity and anyone who did not seem to conform to acceptable standards remained visible long after Klan activity had subsided, as this photograph of a downtown café boldly demonstrates with its "All White Help" neon sign. As late as 1950, when the Shakespeare festival added its first African American actress, she found it difficult to get served lunch or dinner in Ashland establishments unless accompanied by other festival members. This exclusionary trend continued into the 1960s and 1970s, as "Shakespeares" became a derisive term for the summer theater people, and some eating establishments turned away "long-haired hippies" from the college.

Four

LITHIA WATER
AND A PARK

Shortly after his arrival in town, newspaper owner and editor Bert Greer asked, "Why not turn the town into a commercial health spa like Saratoga, New York or Carlsbad, Germany?" Lithia water springs had been discovered east about 4 miles away, and the water could be piped to town if local folks would just pass a bond issue. This was a time when mineral springs were believed to have great medicinal value, so Greer's boosterism was not seen as far-fetched. Even the Southern Pacific Railroad promoted it, seeing the potential for a destination health spa on their route.

Ashland had already established the first park in Southern Oregon where the old flour mill had existed, so merging Chautauqua Park with undeveloped park lands bordering Ashland Creek would create a perfect location for a first-class spa. Voters agreed and in 1914 taxed themselves to pipe the perceived health-giving water to covered gazebos in the park. Soon lithia water was also available at the railroad depot, several hotels, the library, and later, on the Plaza.

The surrounding area had a long history of mineral water use. Native people used the springs to care for their sick and aged far before Euro-American settlement. While the town's motto quickly became *Ashland Grows While Lithia Flows*, actually, the piped water was a blend of lithia, soda, and sulphur waters.

John McLaren, superintendent of San Francisco's Golden Gate Park, was retained to develop landscape plans, and two local businessmen, Gwin Butler and Domingo Perozzi, added additional land and a fountain and statute of President Lincoln, which were unveiled at the expanded park's 1916 dedication ceremony. McLaren's landscapes left plenty of open space for the construction of a sanitarium, casino, and dance hall, which private money would surely add later.

It was not to be. A number of events conspired to end the health resort dream. What is left is a nearly 100-acre landscaped park recognized on the National Register of Historic Places, restored lithia water fountains, and the name Lithia fondly attached to countless businesses and a major thoroughfare.

Bert Greer came to Ashland in 1911, bought the local paper, moved into this house on Granite Street, and began writing editorials promoting the idea of Ashland as a spa-type resort. Meanwhile, Harry Silver, who owned a lithia-producing spring, wanted to develop a resort on his property east of town. He had visited Saratoga Springs and saw the potential for private development, envisioning a golf course, sanitarium, and hotel. The city found a well near Silver's and decided, with Greer's urging, to pipe the water to town, thus setting up a classic argument of what is a city's responsibility to provide for its citizens and what is best left to private enterprise. Put to a vote of the people, Greer's vision for a resort won out as citizens voted to bond themselves for $175,000 initially with a cost over-run increasing the public debt to $225,000.

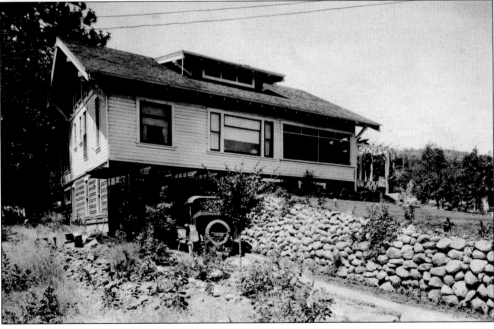

Determined to promote Ashland as a spa town, the Ashland Commercial Club produced a booklet in 1915. Inside this facsimile of a glass of mineral water, the town was described as a resort city with "healing waters." Ashland, it predicted, would be "one of the greatest water-cure resorts in the world." Visitors were urged to mix lithia water with lemon juice and sugar, "producing a delicious, effervescing beverage." Even a lithia song sheet was produced with the ubiquitous glass of lithia water displayed. Three verses, coupled with this refrain, seem to capture the enthusiasm of the day. "Lithia / Lithia / Greatest of blessings / Drink long, drink well / Nature's best gift / Ashland's pure waters come straight from the earth. Strengthens the body, gives life to the weak / Gives life to the weak." (Both courtesy of author's collection.)

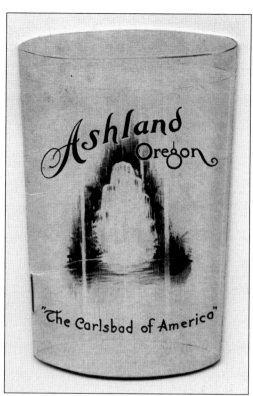

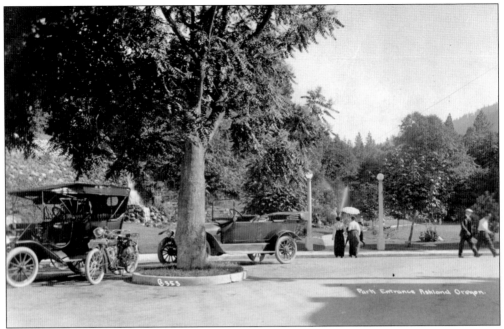

The longtime site of Ashland's flour mill became the entrance to what was first called Chautauqua and later Lithia Park. The old mill, a pig sty, and abandoned sheds standing behind it were removed in 1909. Some preservationists were disappointed that a major early historical structure was being torn down, but the Women's Civic Improvement Club effectively argued for removal.

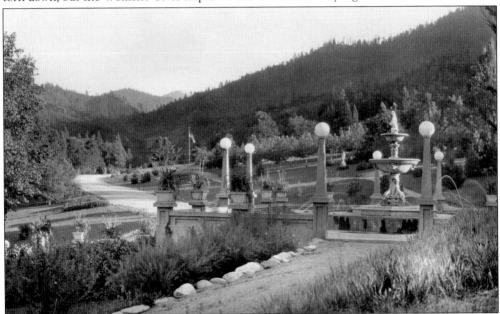

Here are the beginnings of Lithia Park featuring the Butler-Perrozzi fountain, unveiled at the park's July 4, 1916, dedication. Domingo Perrozzi and Gwin Butler were successful Ashland businessmen who purchased the cupid-topped Italian fountain at the Panama-Pacific Exposition in San Francisco for $3,000. A statute of Abraham Lincoln was also purchased by Butler, which was placed on a side hill just beyond the fountain and is visible in the distance.

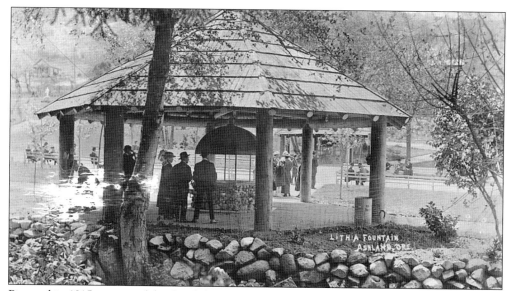

Pictured in 1915 are one of the first lithia water kiosks and a close-up view of the lithia fountain contained inside. This gazebo is close to the creek and contains a surviving fountain where lithia water can be tasted, although the fountain shape itself is significantly changed from the pictured bell-jar look. The hope was that the lithia spring would make the town into a Carlsbad, Germany, where mineral water treatments were very profitable. Trouble with the original wooden pipes resulted in complete replacement with a costly cast iron fix, and while World War I dampened local interest in the spa idea, in the early 1920s, bottling the mineral waters was explored.

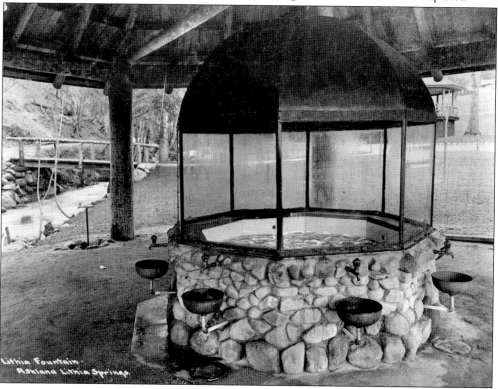

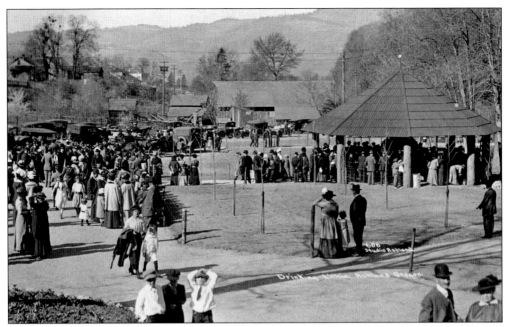

Strolls in the park became the social and recreational thing to do in 1915 and for years after with folks dressed in their Sunday best. Additionally, the focus of this gathering seems to be to try the newly installed lithia water fountain under the gazebo roof pictured to the right.

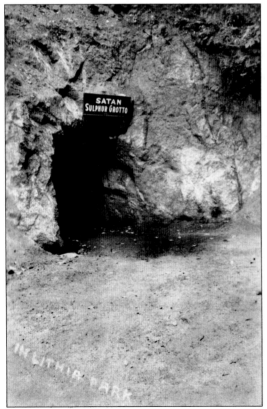

Sulphur water was piped to a cave across Ashland Creek opposite the tennis courts in Lithia Park. It was named Satan's Sulphur Grotto, had eerie blue lights as one entered, and was used as a place to initiate lithia water boosters called Lithians. It was also an irresistible place for children to hide and jump out to scare people. Lined with rocks, sulphur water bubbled up among the stones.

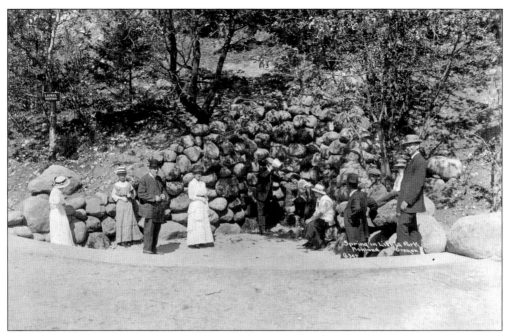

Another sulphur water tasting opportunity existed in Lithia Park upstream from the Grotto near the auto camp's community building. This stone formation exists today minus the sulphur spring. Possibly a staged promotional photograph or part of a group outing, note all of the well-dressed folks waiting for a chance to "take the waters."

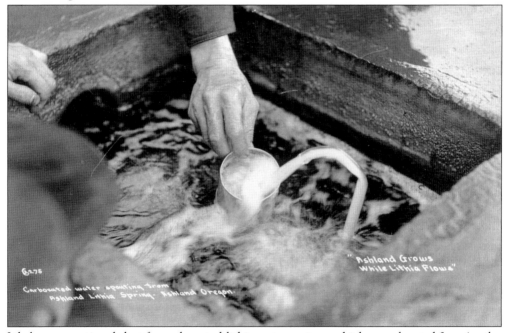

Likely a promotional shot for carbonated lithia water springs, which were located 3 or 4 miles to the east of town, this photograph shows a sampling being done on-site. Note the ever-present slogan of Ashland boosters on this postcard for the development of a spa: "Ashland Grows While Lithia Flows."

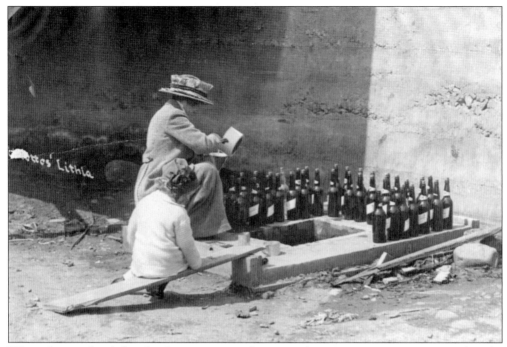

When the city decided to develop its own site for piping the water, some entrepreneurs thought of bottling the product and selling it as table water as well as for medicinal purposes. Pictured are both businessmen and a well-dressed woman filling bottles for sale. Henry Enders sold bottled lithia water from Harry Silver's mineral spring in his grocery store as well as statewide. Lithia water sold for 25¢ a bottle. Enders said he sold hundreds of cases until the Pure Food and Drug enforcers questioned the advertised amount of lithium and found it insufficient. A few of these bottles have survived, becoming collector items of the era.

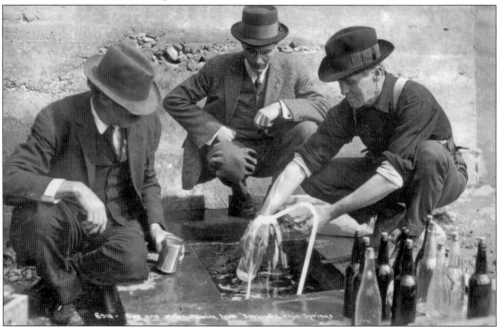

It is interesting that the official program for the Lithia Park 1916 dedication featured the Rogue River Rodeo competition as the major draw. It was a three-day event (July 4, 5, 6) with Ashland's day being the Fourth of July and Medford's and Grants Pass's days to follow. Scheduled rodeo events were held just off East Main Street at the Butler-Walker ranch, where an enormous grandstand that could seat 10,000 was quickly filled, forcing 3,000 spectators to stand. The July 4 park dedication lineup included a Queen Lithia Pageant and parade through town, followed by water sports; patriotic ceremonies; band concerts; the unveiling of the "Fountain of Youth," as the Butler-Perozzi fountain was first called; fireworks; and dancing at two local venues, including the Natatorium. Estimates of 30,000 celebrants came on July 4, and overall, a crowd of 60,000 was estimated! (Both courtesy of author's collection.)

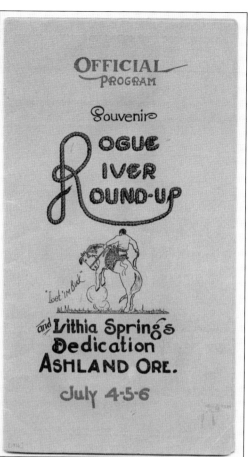

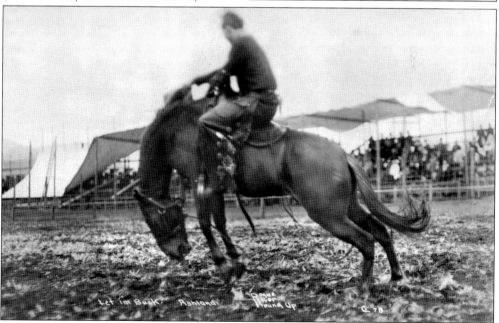

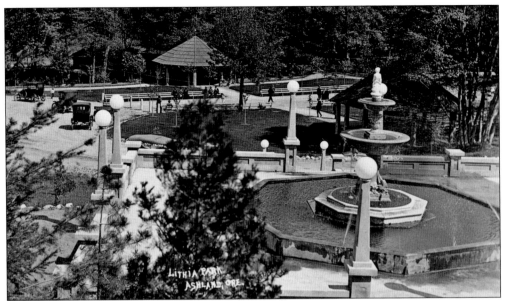

Visible in the early 1920s are, in the background, two lithia water fountains, as well as the Butler-Perrozzi fountain in the foreground. From the outset, Lithia Park has offered citizens a formal garden look and a rustic walking area and bridges along and across a creek that sometimes roars and other times rambles down from the canyon above. Numerous wooden bridges have been destroyed over the years by floods and then gradually replaced. Pictured are both aspects of the park—formal and informal. A kind of promenade between the two lithia water kiosks and the bandstand drew well-dressed visitors often seated on long benches. Family outings along creekside trails were also common.

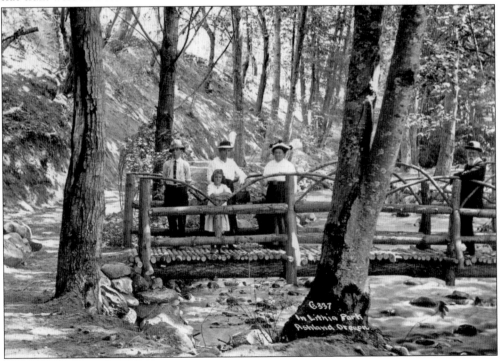

Even before development of upper Lithia Park, the road along Ashland Creek was a popular site for picnics and outings. Hanging Rock was a natural outcropping of sorts very popular for picnics and posed pictures. This could be a Southern Oregon Normal School group because the school "bus" is parked on the road below.

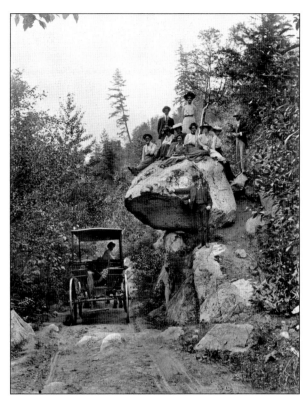

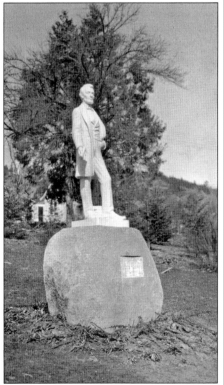

In honor of pioneer Jacob Thompson, Gwin Butler's stepfather, Ashland businessman Butler purchased this marble statue of Lincoln for $2,500 at the 1915 Pacific Exposition in San Francisco and had it placed on a knoll just beyond the Butler-Perozzi fountain. Unfortunately, the statue has been the target of constant vandalism, resulting in underground storage, moving it closer to city hall, and the crafting of several new heads.

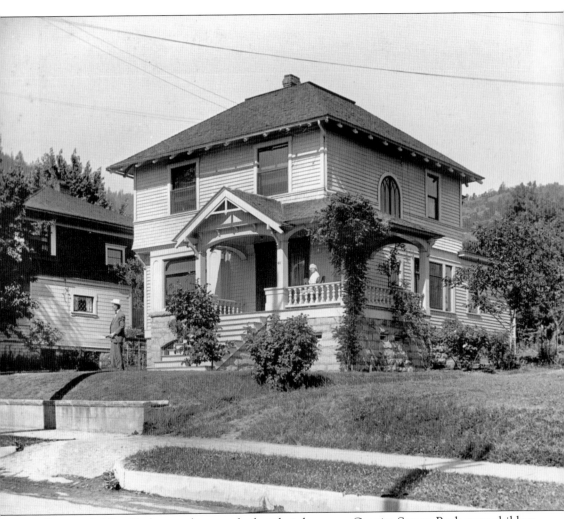

Gwin and Alice Butler are photographed at their home on Granite Street. Both were children of early pioneers growing up at a time when it was still possible to watch Klamath native people camping near Bear Creek, trading for goods. Gwin was a successful merchant, rancher, banker, real estate investor, and public servant, known also as a frugal man who balked at paying 50¢ to have his lawn mowed. He served on the town council and as mayor, and both Butlers were involved in numerous community groups. In addition to a fountain and statute of Lincoln, Butler also left money in his will for a band shell and playground for Lithia Park. Upon his death in 1947, he left a trust fund of $700,000 to be used to help Ashland's needy children.

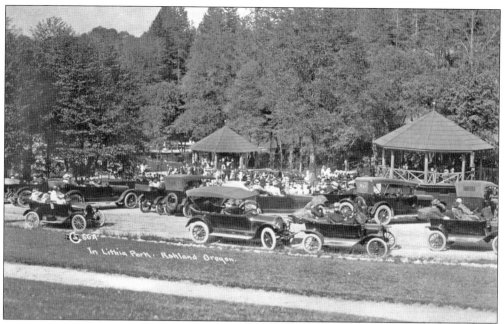

Huge gatherings enjoying Lithia Park were common occurrences, especially on summer Sundays. In the center background is a lithia water fountain with its gazebo roof cover, and to the right is the park bandstand, where a concert is in progress. In later years, a much larger concrete band shell replaced this wooden structure.

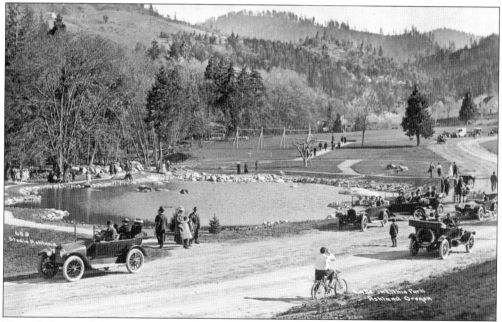

This 1916 view of the upper duck pond shows a scarcity of trees, with the exception of volunteer alder along the creek. Because John McLaren's layout was intended to encourage a mineral springs resort, it was an open design. Today's lawn expanses were originally potential sites for a sanitarium, tearoom, pools, and a casino. By the mid-1920s, resort plans built with private money had waned, while the park remained.

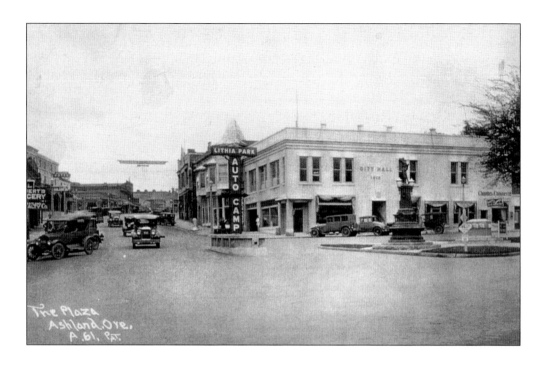

Begun as a free auto camp and later open to travelers for 50¢ and then a dollar, Ashland welcomed visitors to its park and businesses hoping they would stay a few more days. Auto camps offered travelers a place to spend the night where they would not be run off by angry farmers. A "community house" was built for the Ashland campground that included a communal kitchen, piano, and even a dance floor. At first tents were common, but eventually as many as 16 cabins and a store were built. Today the community house is used for the city parks department's offices.

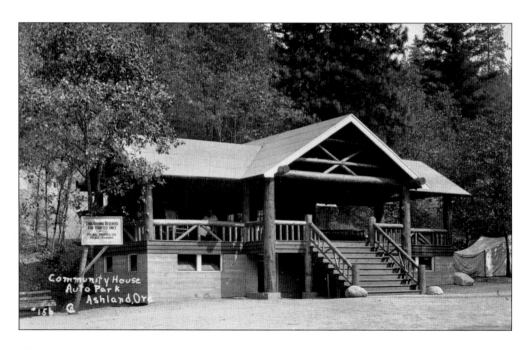

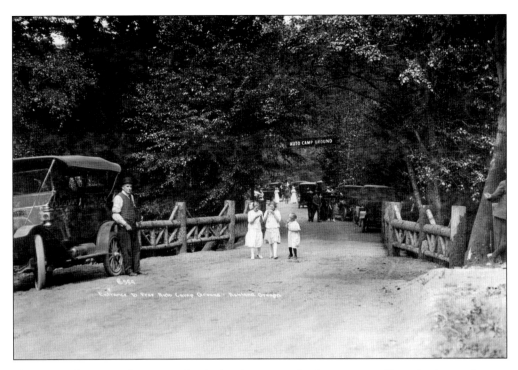

Now a simple approach across a bridge to the city parks department offices, both a park store and entrance to the park campground dominated this site in the 1910s and 1920s, as can be seen in the photographs. Pictured is what appears to be a full auto camp with cars parked along the roadside. Happy children can be seen on the bridge eating something they likely purchased at the park store, which advertised "Refreshments, Groceries, and Accessories" on its false front. A gas filling station adjoined the store. Note the formality of dress on the adult campers.

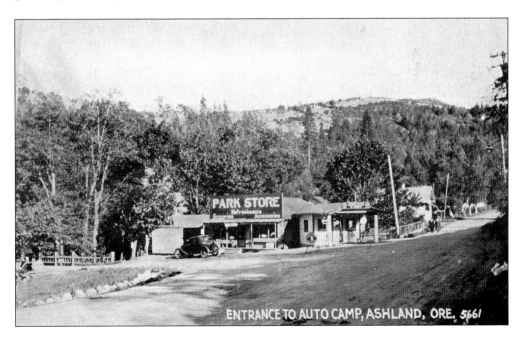

81

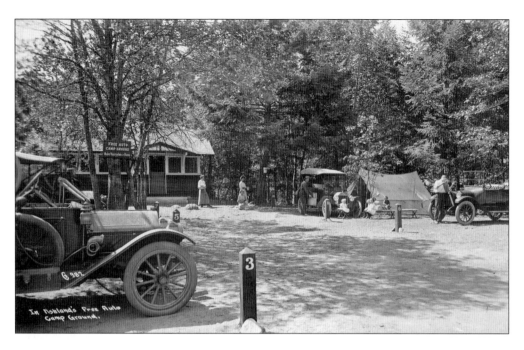

In Ashland's Free Auto Camp Ground.

Traditional family roles seem evident in these views of Ashland's free auto campground. While men tended to the auto's needs, women made tent life as cozy as possible, watched over the young children, and prepared meals. Ashland's camp was one of the first in the nation, and eventually small cabins were made available as well as tent and trailer space. Officially opened July 22, 1915, the campground and most of the remaining deteriorating cabins were finally dismantled in the late 1950s. It had successfully accommodated tourists for more than 40 years. Remaining today alongside the community house is one cabin restored as it might have been.

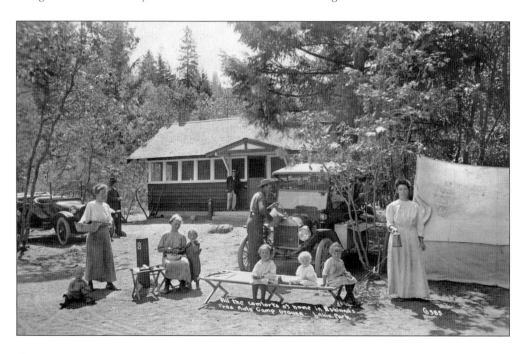

All the comforts of home in Ashland's Free Auto Camp Ground, Lithia Park.

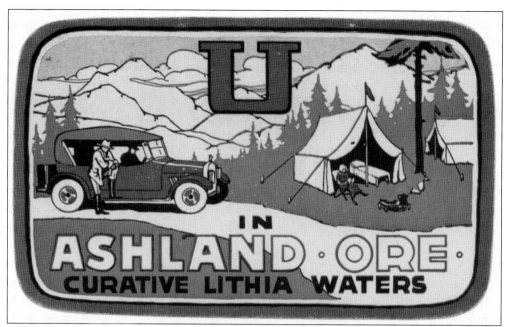

Both luggage labels and auto window stickers were popular proof of one's travels in the 1910s and 1920s. Ashland boosters, with both a park with waters thought to be medicinal and comparable to famous resorts around the world and an auto camp, produced these orange and green souvenirs for tourists. Even business stationary carried the lithia water logo of a glass proclaiming Ashland as "the Carlsbad of America," demonstrated by this 1916 letterhead. Understandably, the real estate firm of Hodgson and Reed seemed eager to join other boosters in the promotion of a mineral water resort town. (Both courtesy of author's collection.)

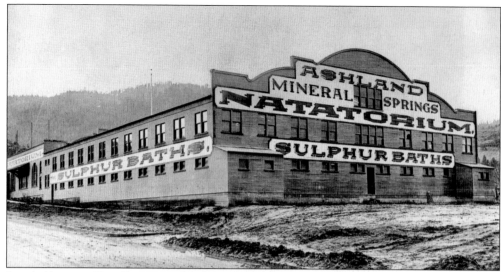

Located between First, Pioneer, and A Streets, the Natatorium was one of the forerunners to lithia resort plans. Open to the public since 1909, it featured two pools supplied by underground sulphur springs, one each for men and women. Spring boards, slides, trapeze rings, and high dives were all available for the adventurous. There was a promenade deck, and a maple wood floor covered the tank that stored water, doubling as a dance hall and skating rink. In 1933, the building was purchased and reopened as Twin Plunges, an outdoor facility utilizing the original two pools of the Natatorium. The building was demolished in 1977, and the Ashland Food Cooperative now occupies the site.

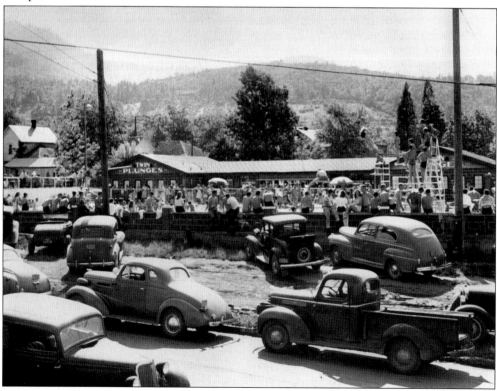

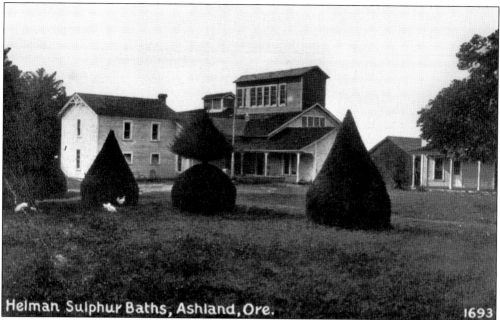

Helman Sulphur Baths, Ashland, Ore. 1693

Native people had long ago discovered and enjoyed a large warm sulphur spring northwest of what would later become the Euro-American settlement area. The idea of using the natural springs throughout the immediate Ashland area had been explored for some time prior to the lithia spa idea. For example, Helman baths, pictured here, were built by Otis and Grant Helman about 1902. It was eventually developed into a large swimming and recreation site. There was a slide in the middle of the pool, and ropes hung from the rafters. Sulphur water was supposed to be a cure for a number of diseases, including rheumatism, and was advertised to be 94 degrees when it left the spring for the baths.

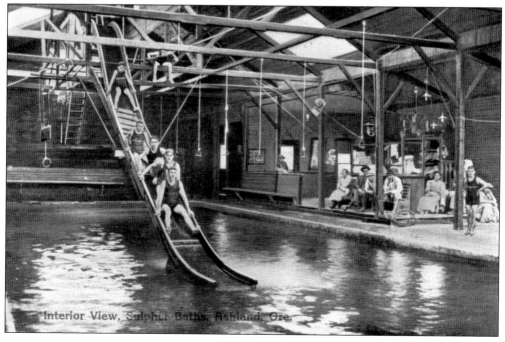

Interior View, Sulphur Baths, Ashland, Ore.

Perhaps the strangest character to set foot in Ashland, stay the shortest time, and leave the biggest legacy was millionaire New York transplant Jesse Winburn. Pictured is his expanded cabin, located in the Ashland watershed and named Sap and Salt after a friend's comic strip. Welcomed initially because he seemed most likely to guide town development as a tourist destination, he left after just a few years, disgruntled with town politics.

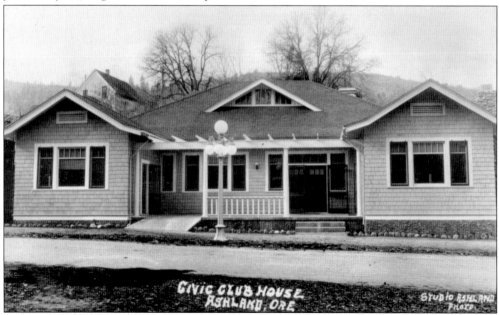

When the Women's Civic Clubhouse could not be finished for lack of funds, Jesse Winburn gave $6,000 to complete the building and bought a $5,000 organ as well. Thinking Lithia Park needed a touch of class, Winburn bought swans for the park ponds. He threw lavish parties for children, offered cash prizes for Fourth of July parade participants, and remodeled the hospital. Appreciative city fathers renamed the road through Lithia Park Winburn Way.

The Fordyce-Roper home, located on Main Street, became a temporary hospital location in 1908, but a faulty flue resulted in a top-story fire in 1909. The house was later moved up Second Street to the corner of Hargadine Street using a horse and winch system and currently exists as the Winchester Inn. In 1910, property on Palm Avenue and Siskiyou Boulevard was purchased for a two-story concrete building designed by Frank Clark called the Granite City Hospital. For a little over a decade, the hospital functioned, until Jesse Winburn, needing care himself, found it lacking, purchased it, completely remodeled it at a cost of $30,000, and deeded it back to the city in 1923. The site of this Granite City Hospital is now occupied by the Student Union Building on the Southern Oregon University campus.

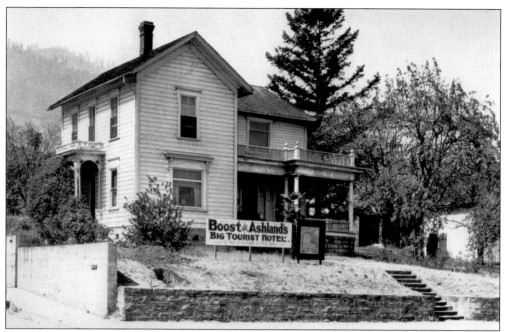

Here is the D. R. Mills house on Main Street in 1924. Notice the sign in the yard advertising the new Lithia Springs Hotel to be built on this site. Included was an additional sign picturing for all to see what would be in place in a year. The hole in the lower left corner of the yard was a result of an earlier ground-breaking ceremony.

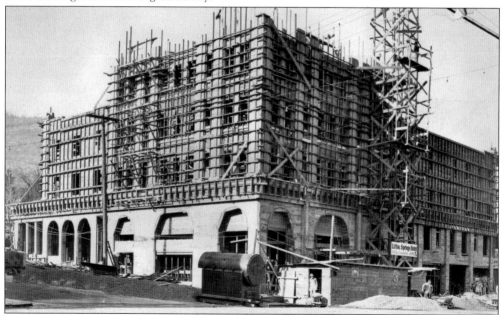

By April 1925, construction of the Lithia Springs Hotel was well underway. Taking up the corner of First and East Main Streets, it officially opened for business on July 1, 1925. A group of Ashland businessmen wanted to attract more tourist business, in part to attempt to revive the health craze for mineral waters. The structure would carry a Lithia Springs logo that is still embedded in the lobby stained glass.

Currently restored and named the Ashland Springs Hotel, this nine-story structure was the tallest building between San Francisco and Portland when completed in 1925. Rooms featured Sealy mattresses with Simmons springs, and most had private baths. Though built initially as a luxury resort hotel, as the idea of a mineral water resort town gave way to tourism based upon a growing Shakespeare festival, the hotel was renamed the Mark Antony in 1960.

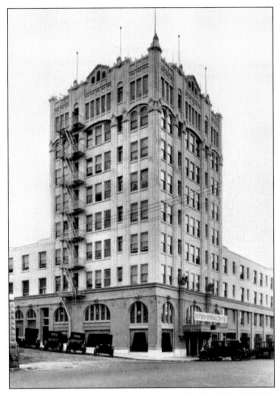

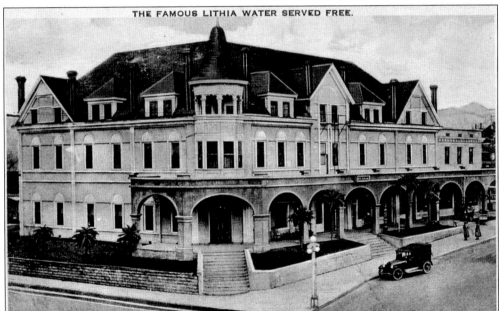

THE FAMOUS LITHIA WATER SERVED FREE.

Ashland's first grand hotel, built in 1888, went through several face-lifts and name changes until it became the victim of a wrecking ball in 1961. In this c. 1930 reincarnation as the Ashland Hotel, note the emphasis on free lithia water served in the lobby, a reflection of the town's on-again, off-again attempt to capitalize on lithia water as a tourist draw. The hotel was located on East Main Street between Oak and Pioneer Streets.

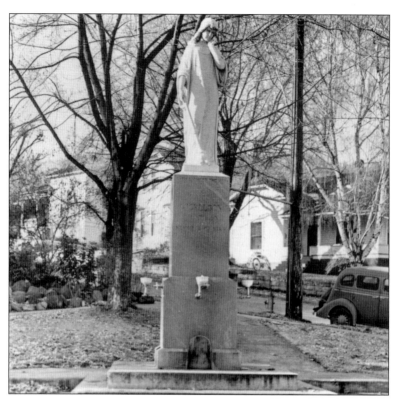

Shown is the Mickelson-Chapman statute in front of the Carnegie Library at the corner of Gresham Street and Siskiyou Boulevard. It was commissioned by Victoria Chapman after the death of her husband, early Ashland pioneer Mike Mickelson, to honor both the Mickelson and Chapman names. It, too, was fitted at one time with lithia water fountains, which are visible in this 1930s photograph.

Designed by architect Frank Clark and constructed in 1909, Ashland's Elks lodge in the 200 block of East Main Street joined the boosterism for lithia water with this 1915 postcard advertisement. Note the promotion of Ashland as a place of "magnificent fruits and flowers" and "soda, lithia and sulphur springs."

The name Lithia stuck even after the mineral spa days had waned. This 1930s Fourth of July parade photograph shows the Lithia Theatre, originally called the Vining Theatre after the brothers who built it in 1913. It joined with at least one hotel and several businesses in identifying lithia with tourism. Located next to the Elks lodge, it burned in 1952.

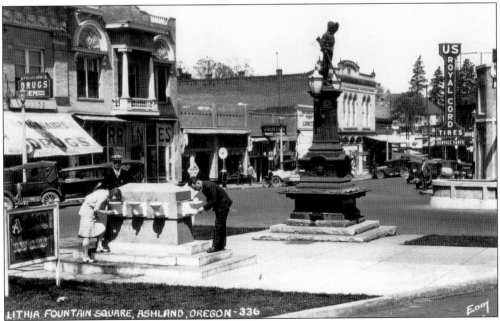

Perhaps the most visible lasting legacy of the lithia water promotion is the restored fountain on the Plaza. In this 1920s photograph, a man and a woman are partaking of the "ice cold" Ashland lithia water advertised on the wooden sign to the left of the fountain. By the 1930s, a huge neon sign had been erected behind the 1910 Carter memorial to draw tourists to the fountain.

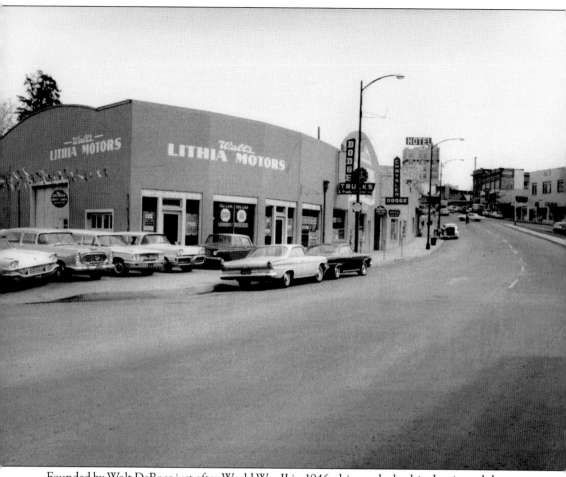

Founded by Walt DeBoer just after World War II in 1946, this car dealership dominated the corner of East Main and Water Streets for over 20 years. Lithia Motors has gone on to become one of the largest auto retailers in the United States, serving both rural and urban populations throughout the West. Lithia Motors license plate frame holders can be seen in most western states, with few new car owners likely making the connection with Ashland's lithia water experiment. Initially a single Chrysler-Plymouth-Dodge store in Ashland named in memory of Ashland's lithia water history, the business has expanded dramatically. Following Walt's death in 1968, son Sid DeBoer and Dick Heimann developed it into a dealership chain of nearly 100 stores now based in nearby Medford, Oregon. Pictured is the original single store location in the 1960s along Main Street. Walt DeBoer donated the creek-side property across Water Street from his store that now makes up Bluebird Park.

Five

ONE MAN'S STUBBORN TENACITY— SHAKESPEARE IN THE WOODS!

Reeling from the loss of its prosperous railroad days and suffering hard times in the 1930s along with the rest of America, Ashland was open to nearly any notion that would bring business and tourists back. Even in those bleak economic times, though, what local college instructor Angus Bowmer was proposing must have seemed at best naive and, perhaps worse, just plain foolhardy. Bowmer wanted to stage Shakespearean plays inside the dilapidated old Chautauqua shell during the middle of a typical hot, dusty Ashland summer in a town nearly 350 miles from any significant population center! To nearly everyone else, this improbable proposal would logically raise the question, "But who will come?"

Bowmer knew Ashland's former Chautauqua history had brought audiences from all over Southern Oregon and Northern California for nearly two-week stays. In fact, it was the view from Lithia Park looking up at the recently decapitated Chautauqua building that gave him the idea for a new festival. He thought the remaining roofless circular walls looked a bit like a drawing of Shakespeare's Globe Theatre. Ashland was a very conservative place, he concluded, and this conservatism could be appealed to because conservatives revere the past. A renewed festival combined with a Fourth of July celebration, which like the Chautauqua had been missing from the town for several years, could work.

What started as a three-day festival in July 1935 has far exceeded Bowmer's wildest hopes. Early reviewers condescendingly referred to the festival as "Shakespeare in the Woods" or "Shakespeare in the Siskiyou Foothills," but if one is like Bowmer, quarterbacking the high school football team and successfully confronting the biggest and meanest school bully as a beginning schoolteacher, maybe one does not know what one cannot do. The festival has survived and grown dramatically since 1935, won an international reputation, and helped the formative careers of many famous actors, including George Peppard, Dick Cavett, Stacey Keach, Monte Markham, Denis Arndt, and William Hurt, to name a few. As Prof. Angus Bowmer often exclaimed, "We didn't know that a repertory theatre in Oregon was an impossibility, so we did it."

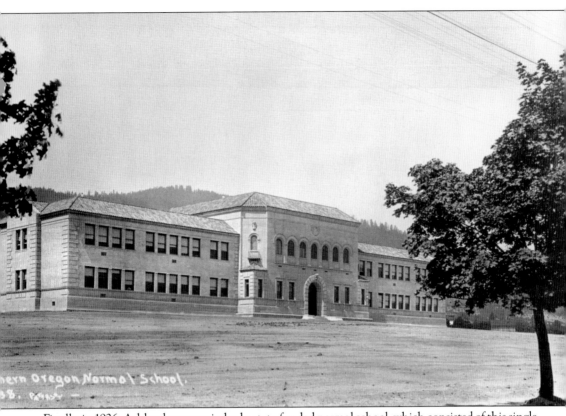

ern Oregon Normal School,
38.

Finally, in 1926, Ashland once again had a state-funded normal school, which consisted of this single building. Six years later in 1931, in what was characterized in Angus Bowmer's 1975 autobiography as pure accident, Bowmer was hired to teach on the recommendation of a distant cousin who was on the faculty. With his master's degree in hand from the University of Washington, Bowmer had sought a normal school position in 1931, finding only two vacancies nationwide! One was in Ellensburg, Washington, and the other was in Ashland, Oregon. He applied to both schools and was bitterly disappointed when he lost the Ellensburg job for lack of experience directing plays. Late in June, a telegram arrived offering him a position at Southern Oregon Normal School from its president, Julius Alonzo Churchill. Much to his dismay, though, upon arrival, he found a school of less than 300 students without a drama department. The sole purpose of the school was to train elementary school teachers. "The single crumb that was tossed my way was a course called 'Play Production,' " Professor Bowmer remembered.

Appalled at finding town children jumping up and down as though they were on a trampoline atop the partially collapsed Chautauqua domes pictured on the left, Ashland's fire marshal ordered the dangerously sagging domes removed in 1933, leaving only a walled shell. Local professor Angus Bowmer, looking for a larger venue than the college provided, latched onto the idea of doing Shakespeare's plays inside the now roofless walls.

While the Oregon Shakespeare Festival's history is well-known, what may not be so obvious are its initial connections and dependence upon Franklin Roosevelt's New Deal "make work" efforts. Previously unemployed Ashland men built this 1935 stage as Works Progress Administration (WPA) workers. Ten men originally assigned to a local street project were transferred to the theater project, creating Ashland's first Elizabethan stage. (Courtesy of author's collection.)

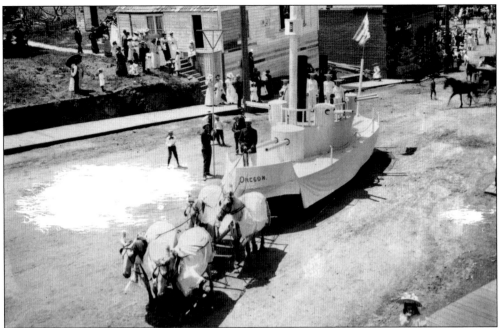

Angus Bowmer realized that Ashland had a long and proud history of Fourth of July parades and celebrations that had drawn people from throughout the region and had been oddly dormant for the previous five years. If he could couple his 1935 Shakespeare experiment with a revival of Ashland's former celebrations, he mused, "Wouldn't it be a tremendous kick-off for us to have flags, bunting, and banners on the street, a parade, bands, fireworks, and crowds of people?" According to an account the next day in the *Ashland Tidings*, Bowmer got his wish. "It would appear that every man, woman, and child in addition to thousands of visitors turned out for the event." Pictured are two Ashland celebrations in the 1890s honoring the battleship USS *Oregon* with a wooden float pulled by a team of horses and Civil War veterans parading on Main Street.

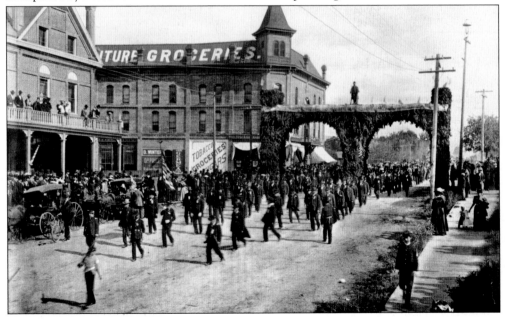

Some feared that the first Shakespeare festival might be a money loser, and therefore 42 rounds of fisticuffs were scheduled to precede the plays on the freshly constructed stage. New Deal workers had removed the old sagging Chautauqua domes, built the original stage, and now provided the boxers from local Civilian Conservation Corps (CCC) camps for the festival's first Green Show. In 1975, Bowmer recalled what might be the most famous festival story in this manner. "I was approached by the celebration committee expressing their concern about a possible deficit from our plays. They asked to use the Elizabethan stage for boxing matches the afternoon of the Fourth and seemed relieved when I reassured them that such an event would have appealed to Elizabethan audiences." Much to Bowmer's glee, the plays made a profit, making up for the financial loss from the prizefights.

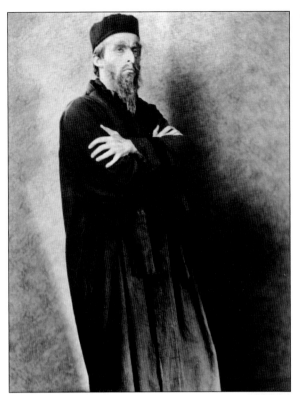

"My Shylock, as can be seen from the picture taken at that time, was pretty scroungy and quite obviously villainous. I suspect that it was a groping portrayal of a very narrow stratum of that richly human character and bore little resemblance to my performances of the role in later years," Bowmer opined about his 1935 performance in his autobiography. He would continue to reinterpret the role at least six more times. (Courtesy of OSF.)

Always resourceful and innovative at adapting the old Chautauqua site, Bowmer had to deal with the same acoustical problem that plagued performances in the 1917 Chautauqua building. "The bare circle of cement walls created a very strange echo chamber effect in the very center of the auditorium, so we eventually planted beans that clung to strings stretched up the walls. This helped to break up the reverberation and also provided several messes of beans for the always hungry actors." (Courtesy of OSF.)

Even after the Shakespeare festival was well established, an actor offended some locals by going to a barber shop wearing shorts. For several seasons, Angus Bowmer lectured his cast members, warning men not to wear shorts on Ashland streets and never to wear shorts with sandals! "That would be calamitous," William Oyler recalled Bowmer exclaiming in Oyler's history of the festival. Nevertheless, Ashland summer days could be just plain hot, and without an indoor stage facility to practice sword fights on, actors, including Bowmer, pictured in the center here, rehearsed in attire not appropriately street worthy. (Courtesy of OSF.)

Dramatics

● Under the direction of Angus L. Bowmer, dramatics have found a definite place in the extra-curricular activities of the Southern Oregon Normal School Associated Students.

This year has been particularly successful. THREE MEN ON A HORSE, produced for homecoming, October 30 and 31, was received by an appreciative audience both nights of its production.

GHOSTS by Henrik Ibsen was the second production to meet with the approval of the people of Southern Oregon. It was so well received that the public demanded eight showings. GHOSTS had a splendid cast made up entirely of students.

ANGUS L. BOWMER

The annual Shakespearean festival, which originated at Southern Oregon Normal School, is being recognized with increasing enthusiasm by theatre circles throughout the West, and has grown into one of the leading civic interests of Southern Oregon. The Oregon Shakespearean Festival Association sponsors the production of Shakespeare in the only Civic Elizabethan theater in the world.

To further the development of drama in Southern Oregon Normal School, Alpha Tauri was organized as a dramatic honorary society when the institution was young; it has served its purpose well.

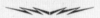

A scene from Shakespeare's "Twelfth Night" during the third annual Shakespearean Festival

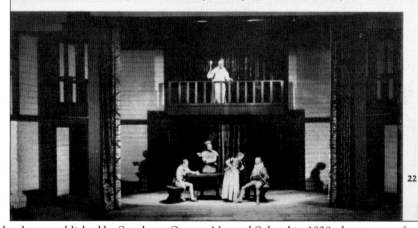

22

A yearbook was published by Southern Oregon Normal School in 1938, three years after the first Shakespeare festival. This page shows Angus Bowmer's skill at promoting the fledgling Shakespeare festival while in its infancy. In reality, the college did not have a Theatre and Speech Department until 1963, a full 32 years after Professor Bowmer's arrival. Nevertheless, under the caption "Dramatics," Bowmer introduced yearbook readers to this extracurricular opportunity, mentioning successful plays performed that school year and pointing out that the annual Shakespeare festival was a product of the normal school and was constantly gaining recognition regionally. What's more, "the Oregon Shakespearean Festival Association sponsors the production of Shakespeare in the only Civic Elizabethan theatre in the world," Bowmer noted. Presented by his mostly student cast, the bottom pictured 1938 scene on the original stage inside the Chautauqua walls was the third year in a row that *Twelfth Night* was performed.

It was not until the third year that a souvenir program was produced for the festival. "We had cheap little throw away programs for those first two years but I have always been proud that the first one read: 'The City of Ashland presents—The First Annual Shakespearean Festival.'" Bowmer went on to say, "The word 'annual' is proof again that we had permanency in mind, even in those improbable and innocent days." Pictured are the 1937 and 1939 season programs, which advertised four plays. In 1939, the plays were enjoyed by 2,000 patrons. Interestingly, the 1937 back cover advertised "Ashland's Three Great Attractions" as the Lithia Hotel, Lithia Park, and Twin Plunges spring-fed swimming pools. (Both courtesy of OSF.)

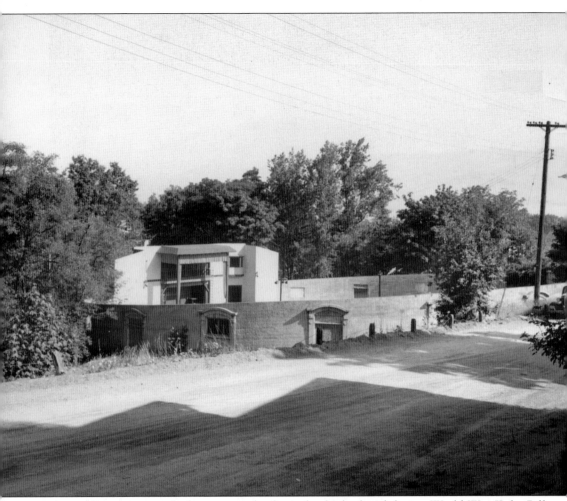

Angus Bowmer was asked to restart the festival, which closed during World War II, by Bill Healey of the chamber of commerce and Robert Dodge of the prewar festival board. "No, but if the people of Ashland want to start it again, I am available for a price," Bowmer responded. His asking price was $1,000 a year. "When the Festival was reorganized in 1947," he stated, "I was determined to be a professional." Pictured is the 1947 stage built of raw scrap lumber scrounged from the dismantled World War II Camp White. Even the facade was unpainted wood. The crude structure lacked restrooms, with the only one existing for both cast and audience members next door in a YMCA building. Hard wooden benches and folding chairs and no intermissions meant long, uncomfortable sits. That first postwar season sported a souvenir program cover featuring Bowmer as William Shakespeare, but unfortunately, according to Bowmer, it included very mediocre productions of *Hamlet*, *Macbeth*, *Love's Labour's Lost*, and *Merchant of Venice*. Note the old 1917 concrete Chautauqua wall surrounding the stage in this 1949 photograph.

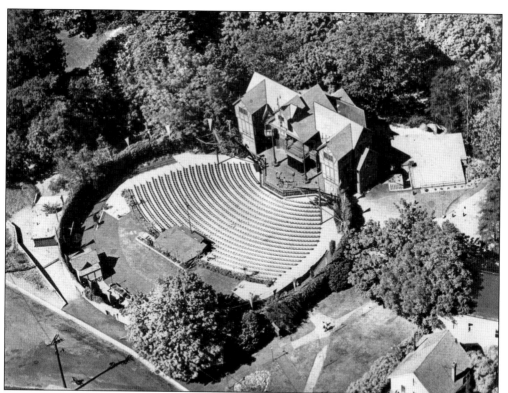

In 1958, Ashland's fire marshal condemned the 1947 building, requiring leveling of the structure at the end of the 1958 season and starting a serious fund-raising drive to find $250,000 for a new Elizabethan theater. Bowmer credited Medford's Alfred Carpenter as the person most responsible for getting it done. Anonymously, Carpenter matched every dollar raised in Ashland with his own donation. Designed by Richard Hay, this stage has successfully served the festival for 50 years. Pictured is a view of the new complex around 1960 with seats at a much steeper angle than before and a special 1970 afternoon music performance.

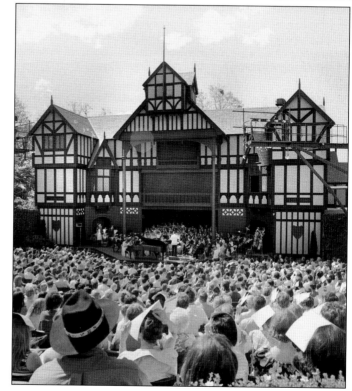

Festival seasons gradually expanded until, by the 1950s, productions played the entire month of August, seven days a week. "Stay four days, See four plays" had become a clever promotional slogan by the late 1950s. The mid-1950s Chautauqua Walk photograph captures the month-long season schedule and makes the link between one of the old paths taken by Chautauqua visitors and the newer paved and signed walkway to the same location for cultural entertainment. Chautauqua Walkway is currently framed by Chateaulin Restaurant and Shakespeare festival offices. Near the top of this walk sat the YMCA building that had previously been, as pictured, a Grand Army of the Republic (Civil War veterans) meetinghouse. This is the current site of the Angus Bowmer Theatre.

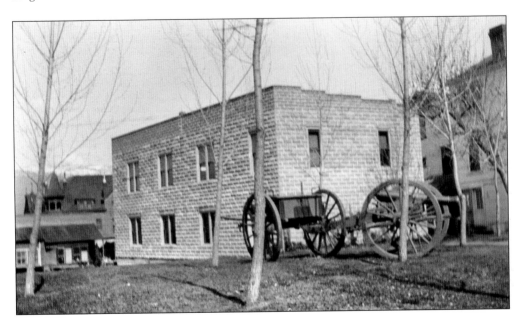

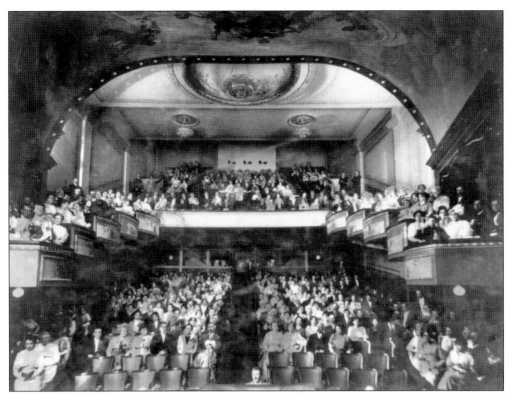

Both town motion picture houses were used for indoor, afternoon, non-Shakespearean performances before the Bowmer Theatre was built. Until the Lithia Theatre burned in 1952, Bowmer's festival companions produced a winter festival in the plush old theater house, which seated an audience of nearly 600. While elegant, the Lithia had few backstage amenities, with offstage space nearly nonexistent and inadequate dressing rooms under the stage. In the following decade, the Varsity Theatre would be the venue for indoor matinee performances. "There was no dressing room space at the Varsity so we made a virtue out of necessity and formed a parade from our own theatre through the town, in full costume and makeup, singing songs, accompanied by the rhythmic banging of a bass drum and tambourines," Bowmer fondly remembered in his autobiography. These performances at the motion picture houses indicated there *was* an audience for non-Shakespearean afternoon presentations and a real need for an indoor theater.

By 1967, the festival was playing to over-100-percent capacity for the season as folks sat and stood through *Pericles, Antony and Cleopatra, The Taming of the Shrew,* and *Richard the Third.* A comic opera, *Maid of the Mill,* was also performed that year at the Varsity movie theater in the afternoons. *The Taming of the Shrew* was sold out for the entire season, from July 24 to September 10, before opening night! Something had to be done to increase capacity. The answer was a new, 600-seat indoor theater, pictured in this architectural drawing from 1968 and pictured completed by 1970 thanks to significant donor Julie Carpenter Daugherty. It was named the Angus Bowmer Theatre.

Six

THE REINVENTION OF ASHLAND, OREGON

Chamber of commerce brochures for Ashland's 1952 centennial identified "lumber and Agriculture" as the town's industries. A dozen lumber mills dotted the landscape in what many described as a conservative, predominately blue-collar town. However, by the early 1970s, a major downturn in fortunes of resource-based industries resulted in boarded-up storefronts that gave the main business section a ragged, almost abandoned look. This is clearly not the Ashland of today. What confluence of forces came together in early-1970s Ashland to cause a very conservative small town to be transformed into a place that regional and national media love to tout as an oasis of enlightened tolerance and progressive ideas?

It only seated an additional 600 patrons, but the 1970 debut of an indoor theater to compliment the long-existing outdoor Elizabethan stage became a major catalyst for change. No longer restricted to summer months, the new Bowmer Theater made possible nearly nine months of productions and created a corresponding demand for places to stay, eat, and browse. Concurrently, Ashland had become a kind of mecca for counterculture folks looking for inexpensive rents and a place to try their hand at a kinder, gentler version of capitalism. This "hippie" entrepreneurial invasion would result in a variety of interesting enterprises in previously vacant or under-used shops. Once a longer, more stable market was recognized by traditional business persons, bed-and-breakfasts and numerous restaurants began to appear as well.

Larger theater offerings also enhanced Ashland's image as a retirement haven. Real estate agents refer to a kind of self-selection process that resulted in an influx of well-educated, affluent, humanities-oriented retirees coming for the theater, music, and low crime rate. Much of this influx was from California, where home equity increases have historically been legendary.

A 1985 anniversary book commemorating the Shakespeare festival's first 50 years contained a perceptive line: "With the opening of the Bowmer Theatre nearly everything about the festival changed." It would not have been hyperbole to have continued the thought and claimed that it had had a similar impact on the town. Ashland has clearly reinvented itself as a destination rather than a place on the way to somewhere else.

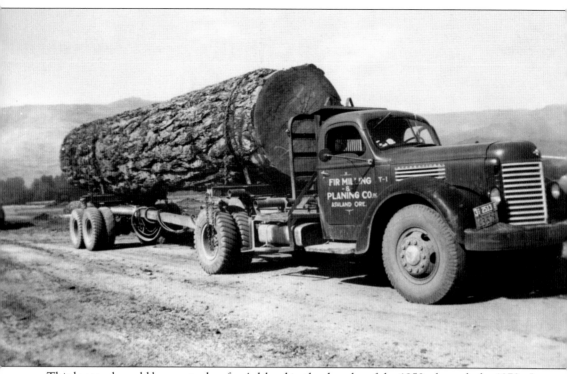

This log truck could be a metaphor for Ashland in the decades of the 1950s through the 1970s. In the 1950s, the number of sawmills grew from 3 to 13, with some running three shifts a day. It was all part of the post–World War II building boom that meant smoke and pollution but also jobs. In 1953, these mills paid more than $2 million to their direct employees in town, and payments to subcontractors such as loggers and haulers were nearly as much. The Ashland Chamber of Commerce estimates that the lumber industry was generating $32 million in purchasing power in the community each year! With large stands of timber surrounding Ashland and reforestation projects in place, the chamber predicted that the wood products industry would thrive well into the future.

Marjorie O'Harra, life-long Ashland resident and historian, has characterized Ashland after World War II as a community "increasingly dependent on the wood products industry because of an increasing demand for lumber nationwide." Small, family-owned mills with log ponds such as the one pictured here meant good-paying jobs until large stands of trees became less available for local operations.

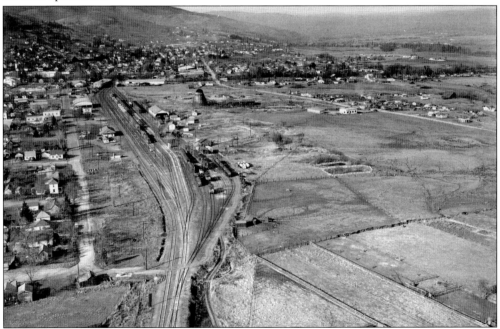

Pictured in the railroad district around the 1960s is a "wigwam" burner used by a local mill to dispose of wood product waste such as bark and chips. Every mill, large or small, relied on one, which led to soot covering porches and cars, but that was just a fact of life for those who lived nearby. Over time, air quality standards would put an end to these symbols of the area's resource-based economy.

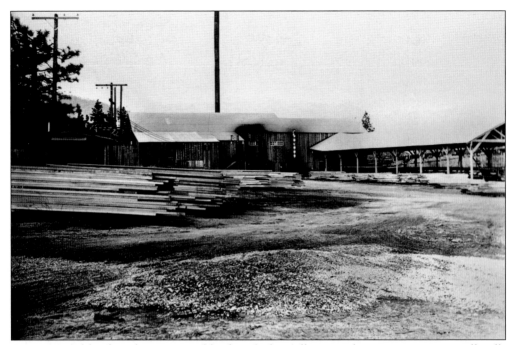

Longtime Ashland residents can readily identify this valley scene because numerous small mills dotted the countryside. Eventually competition from larger-scale operations in Medford, such as Boise Cascade and Weyerhaeuser, coupled with economic recession and new regulations, hit the local sawmills hard.

In the 1950s and 1960s, Plaza businesses reflected a working person's needs. Not yet the site of boutiques, specialty shops, and restaurants, it was a place where one could buy a pair of Levis to wear to work to a family-owned wood products operation or to Medford's larger mills. Pictured is one of the Plaza department stores, the Park View.

In a town better known for Shakespeare and sawmills than Camelot, presidential candidate John F. Kennedy visited Southern Oregon College in the spring of 1960. Private planes had replaced private railcars as the vehicle of choice for candidates; thus Kennedy flew into Medford and then was driven to Ashland for a coffee reception and speech. Senator Kennedy, in a battle with Oregon favorite son Wayne Morse, accepted Prof. Arthur Kreisman's invitation to come to Southern Oregon College as well as to Kreisman's home on Liberty Street for a coffee. Open to the public, nearly 300 Ashlanders descended upon Kreisman's backyard and living room! College campuses had been friendly territory for the youthful senator described by an *Ashland Daily Tidings* reporter as "tall, tanned, and fit." He would go on to decisively win the Oregon primary. Ashland's vote paralleled statewide returns, with Morse finishing a distant second.

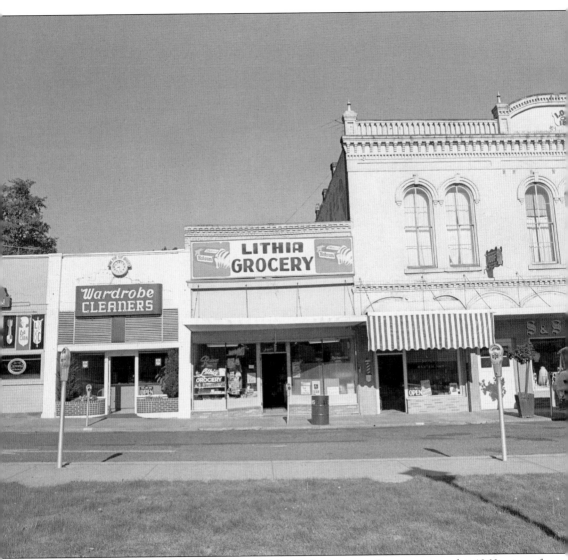

In 1965, sixty-five thousand tickets were sold for Shakespeare performances, yet this 1960s view of the Plaza showed little impact from tourism. Off-season, before the indoor theater was built and the tourist season expanded, meant a continued struggle for local businesses. Downtown got a major face-lift later in the decade with new landscaping and removal of the parking meters in an attempt to appeal to tourists. Lance Pugh remembered buying Lithia Grocery, pictured here, in a 2005 *Ashland Tidings* article. "My wife, Annette and I bought Lithia Grocery in 1972, converting it from a small town Mom and Pop grocery to a counter-culture deli and bazaar. When we came to town nearly half the shops were boarded shut and the festival ran a summer-only program. Times were lean and it took a flood of hippies to get things rolling." Lance further reminisced, "Ashland had become the focus of the counter-culture in southern Oregon. Weekly visitations by commune members from Hilt to Takilma swept into the Plaza to socialize. Plenty of locals had their blood pressure raised by the sight of loincloths, buckskins, and diaphanous gowns."

Before the interstate highway bypassed Ashland, as many as a dozen gas stations lined Main Street. This 1960s picture shows a defunct service station at the corner of Second and East Main Streets. Completed in the summer of 1966, Interstate 5 skirted around the town, leaving Main Street looking drab throughout most of the decade and in serious need of revitalization.

An early-1960s view looking into the Plaza caused some citizens and community leaders to become concerned about the general unattractiveness of downtown. The city's Central Area Plan concluded, "Visually the downtown gives a rather negative impression. Most buildings and store fronts are old; and almost no landscaping is provided along Main Street." A restrictive sign code, planters, trees, landscaping, and more attractive lighting were added in the late 1960s.

THE BEACHBOYS

IN

Concert

March 6, 1966 — 3:00 P.M.

S.O.C. GYMNASIUM

STUDENT $2.50 № **1717**

Southern Oregon College seemed to reflect the decade known as the 1960s. College president Elmo Richardson began the era claiming the college was the largest industry in town. The beginning of the baby boom was boosting college enrollments, and the popular "surfin' sound" of the Beach Boys could be heard in concert in 1966 in the school gym. Four years later, the student unrest that appeared to be sweeping across college campuses as a result of the 1970 Kent State College campus shootings could be found here as well. First-year college president James Sours agreed to lower the American flag to half-mast for a day, resulting in two groups of students encircling the flagpole in front of Churchill Hall. One group shouted "Peace" and the other "Bomb Hanoi!" Sours was threatened with loss of his job or at least censure by a Jackson County veterans group for having lowered the flag. In time, cooler heads prevailed largely because of Sours's efforts. (Courtesy of author's collection.)

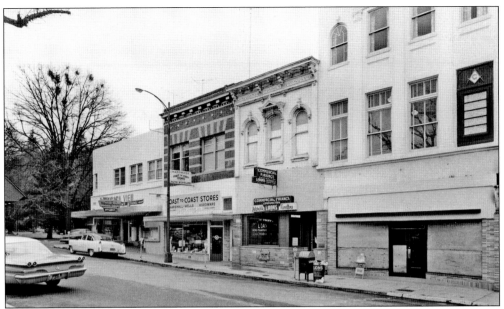

A less-than-appealing Plaza is captured in these two 1960s photographs. The Plaza, initially a thriving economic site and later the proud entrance to Lithia Park and an area where one could purchase the necessities of life from a variety of stores, was increasingly giving way to boarded-up storefronts. Slowly at first, artists and craftspeople opened studios and shops in former business sites that now offered cheap rents. Matt Fry, the longtime Ashland businessman who developed the Rare Earth shop on the Plaza, has remarked that when he came to town in 1969 it was for the cheap rents. "I had no idea Shakespeare existed, there were just lots of vacant buildings." William Oyler, author of a history of the festival, found himself "appalled by the number of vacant stores in the main business section and the abandoned look of the Mark Antony hotel in July, 1969."

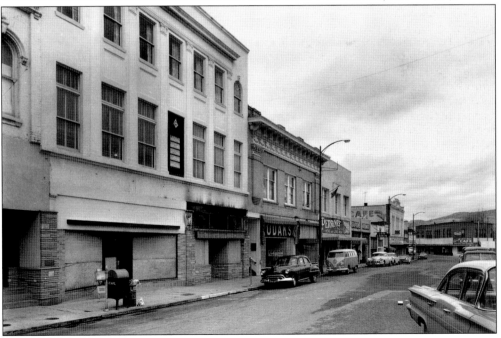

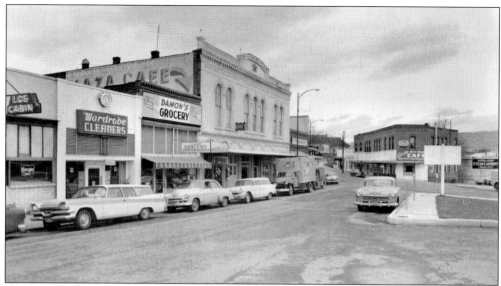

At first, Ashland business owners feared the 1966 Interstate 5 highway project. Old Highway 99 would no longer be the main north-south route drawing travelers to town. Some simply thought the town would go broke. Others saw the need for downtown to change and attempt to capture the tourist trade increasingly being generated by the Shakespeare festival. The idea of gentrification of the downtown area to cater to tourists was not seen as the answer by everyone. Some small business owners complained that an emphasis on tourism and the resulting rent increases would push them out. Writing just a year after the opening of the new Bowmer indoor theater and the festival's much-expanded season, William Oyler noted, "The influx of tourists has contributed to the change in core area business establishments. Now there is a proliferation of curio shops and galleries."

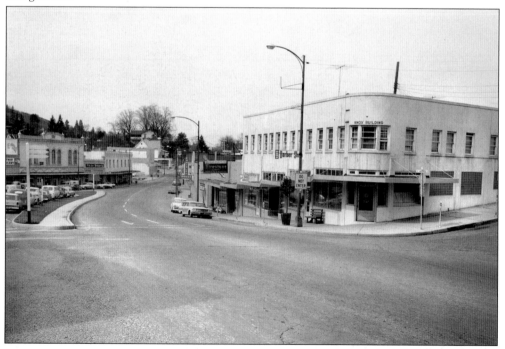

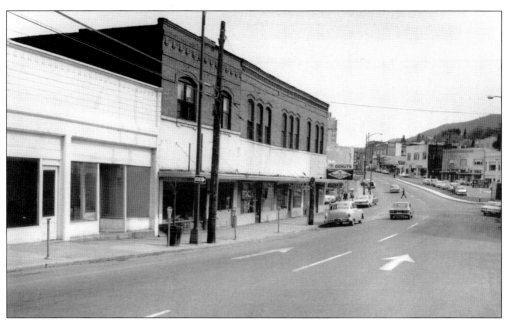

These scenes show North Main Street looking into the Plaza before and during the removal of a building, which was part of a transition opening up the Plaza area. Bluebird Park replaced the building pictured being torn down, and more attractive, open landscaping with an absence of parking meters dressed up the area over time. In 1966, the city paid a consultant $36,000 to study the problems of a bleak-looking downtown and to make suggestions. The resulting report provided the following advice: remove all parking meters in the city, promote the Shakespeare festival, and strengthen the sign ordinance. The first photograph was taken from Church and North Main Streets, while the second shows North Main and Water Streets.

Downtown changed from a local service area to a place where tourists could eat, view art, and buy high-end clothing, gifts, and souvenirs, but it took time for this transition to remake the town core. Groceries, haircuts, and hardware would eventually need to be purchased elsewhere. These two photographs show the same area in the early 1960s as anything but "artsy-craftsy" and a decade later with the beginnings of street landscaping and freshly planted trees yet with many local services still in place. Ashland continued to offer newcomers small-town amenities, a striking physical setting, and increasing cultural opportunities as the theater schedule expanded. It would take a couple of decades, though, for Main Street to be transformed into the current tourist mecca.

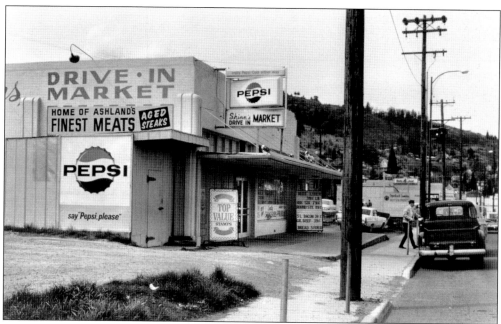

Lithia Way, like Main Street, was not a particularly attractive streetscape in the 1960s, before a strict sign ordinance and landscaping were in place. Even before freeway construction, which re-routed traffic off of Main Street, there was a need to modify traffic flow downtown. In 1956, Lithia Way was engineered to take northbound traffic one way, while Main Street became the southbound route. As one of these pictures demonstrates, the backs of business buildings are not especially aesthetically pleasing, and both photographs show a rather scruffy town in poor condition. Continued long-range planning has resulted in a far more visually pleasing, but in some residents' opinions, less genuine downtown.

Having never fully recovered from the Southern Pacific Railroad's 1927 decision to discontinue most passenger train traffic through Ashland, Fourth Street looked particularly abandoned or at least as tired as the rest of town by the 1960s. The former fire station and jail had become an auto repair building, and the former rooming house across the street had fallen into decay. Currently both buildings have been fully restored, with the rooming house now catering to an upscale tourist crowd primarily fueled by theater patrons. A dilapidated eyesore pictured here as late as 1991, the former Peerless Rooms was restored by Crissy and Steve Barnett into a six-room bed-and-breakfast, helping to foster the rejuvenation of the long-neglected railroad district.

Pictured is the E. K. Anderson town home on East Main Street being bulldozed in the early 1970s. While there was much outrage over the loss of the Ashland Hotel a decade earlier in 1961, this event was the proverbial "straw that broke the camel's back" concerning historic preservation. Individuals began to buy and restore old homes, and Mayor Archie Fries appointed a commission of five to serve as the city's first official Historic Preservation Committee. This has led to the designation of several historic districts in town, including Siskiyou-Hargadine, downtown, Skidmore-Academy, and the railroad district.

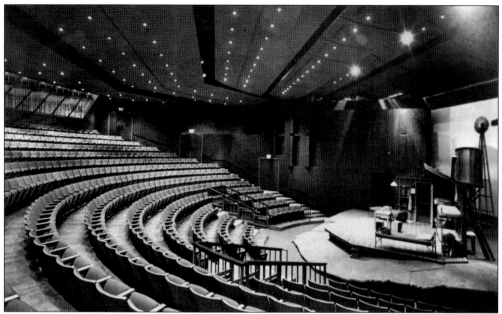

The opening of the Angus Bowmer Theatre in 1970 greatly extended the festival season into spring and fall. It also made possible both matinees and performing two plays at once. Later in the decade, the Black Swan was added, allowing an even greater array of plays to be performed. Throughout the 1970s, independent writers, consultants, and other professionals were drawn to Ashland as its reputation continued to grow. Perhaps by design or perhaps by ironic coincidence, the Bowmer Theatre was built for a town with a heavy wood products past. All of the major support structures are laminated wood, including one enormous beam that weighs 11.5 tons! Designer Richard Hay incorporated the feel of audience and actors both being in the same room by placing all 600 seats within 55 feet of the stage. (Both courtesy of OSF.)

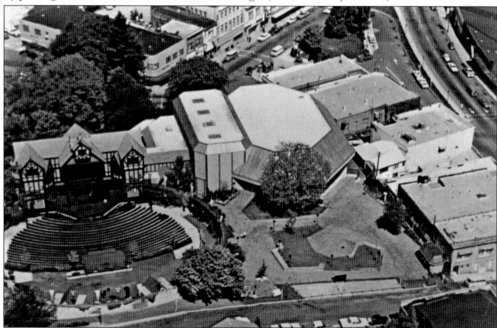

By the 1970s, Angus Bowmer had ample reason to smile. Three theaters were in place that could seat nearly 2,000 theater aficionados between them, and one even bore his name. He had witnessed the remarkable transformation of a once politically conservative and, at times, economically depressed town into one lauded for its progressive politics and theater-driven tourist economy. Always graciously praising the efforts of others, Bowmer could take considerable satisfaction in the fact that his influence was a major reason Ashland had developed as it did. Increasingly recognized as a cultural destination, as a theater and university town with upscale shops, restaurants, art galleries, bookstores, bakeries, and coffee shops, Ashland had reinvented itself, and in no small part, this transformation was the result of one man's unrelenting drive. Angus Bowmer died in 1979, leaving a legacy that seems to support those who believe it is the person, rather than the times in which one lives, that cause great things to happen. (Courtesy of OSF.)

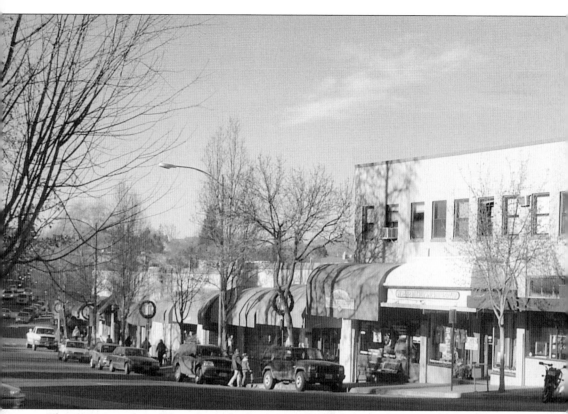

This 2009 view from Water Street looking toward the Plaza shows the refurbished look hoped for in the 1970s downtown plan, with awnings, mature trees, an absence of parking meters, and coordinated painted building facades. Midway down the block is Nimbus, originally founded in 1971 as a leatherworks shop in what was then one of many empty buildings. Belts, wallets, leather coats, deerskin bikinis, and stained glass were crafted and sold here. Lance Pugh remembered in a 2005 *Ashland Daily Tidings* article that the store kept late hours, until after the festival plays ended, in an attempt to capture the theater crowds. Now owned by Ken Silverman, who started working there in 1974, Nimbus has become an upscale clothing store, which Pugh has characterized as a "metamorphosis," a term that could be applied to most downtown storefronts.

Even in winter months it is hard to find parking on the Plaza, where former fraternal lodge buildings now house restaurants and specialty shops. The chamber of commerce promotes these small businesses by working closely with the city to enhance support for those seeking to relocate here or further develop their existing business. With many of the owners of local shops and restaurants living and working in town, shopping and dining is often more personal and therefore attractive to travelers from large urban areas. Galleries, bookstores, specialty clothing stores, shoe stores, jewelry stores, boutiques, spas, salons, coffee shops, wine bars, and outdoor-sport stores are plentiful. Retail shops are busiest during summer months, when visitors are drawn to the theaters as well as quaint shopping.

Looking into the Plaza in this current photograph with the former Odd Fellows Hall dominant on the right, downtown is more than Abel Helman might have hoped for and certainly more than he could have imagined when he provided land in front of his flour mill for a business section to develop. It is a significant improvement over the rather dismal look of the Plaza in the late 1960s and early 1970s. With the oldest and largest regional theater company in the country offering 11 plays in three different theaters, the Shakespeare festival's rotating repertory draws a continuing stream of visitors from mid-February through the month of October. Behind these buildings is Calle Guanajuato, named for Ashland's Mexican sister city. Here, during the theater season, visitors can stroll by local artists selling their wares along Ashland Creek.

SELECTED BIBLIOGRAPHY

Atwood, Kay. *Mill Creek Journal: Ashland, Oregon, 1850–1860.* Ashland, Oregon: Kay Atwood, 1987.

Bowmer, Angus L. *As I Remember, Adam.* Ashland, Oregon: Oregon Shakespearean Festival Association, 1975.

Davidson, Janelle. *Ashland—An Oregon Oasis: An Oregon Documentary.* Burt Webber (ed). Medford, Oregon: Webb Research Group, 1995.

O'Harra, Marjorie. *Ashland: The first 130 Years.* Jacksonville, Oregon: Southern Oregon Historical Society, 1981.

———. *Ashland in Transition: 1980s and 1990s.* Ashland, Oregon: Ashland Daily Tidings, 2000.

Oyler, Verne William Jr. *The Festival Story: A History of the Oregon Shakespearean Festival.* Ph.D. dissertation. Los Angeles: University of California at Los Angeles, 1971.

Walling, A. G. *History of Southern Oregon.* Portland, Oregon: A. G. Walling Publishing, 1884.

ACROSS AMERICA, PEOPLE ARE DISCOVERING SOMETHING WONDERFUL. THEIR HERITAGE.

Arcadia Publishing is the leading local history publisher in the United States. With more than 5,000 titles in print and hundreds of new titles released every year, Arcadia has extensive specialized experience chronicling the history of communities and celebrating America's hidden stories, bringing to life the people, places, and events from the past. To discover the history of other communities across the nation, please visit:

www.arcadiapublishing.com

Customized search tools allow you to find regional history books about the town where you grew up, the cities where your friends and family live, the town where your parents met, or even that retirement spot you've been dreaming about.